Beverly Pepper
Three Site-Specific Sculptures

by Barbara Rose

SPACEMAKER PRESS

Washington, DC

Cambridge, MA

Dedicated to Rebekah Edmonde Aubry

Front cover:
Palingenesis, Zurich, Switzerland

Publisher: James G. Trulove
Art Director: Sarah Vance
Designer: Elizabeth Reifeiss
Editor: Heidi Landecker
Printer: Palace Press International

ISBN: 1-888931-14-0

Acknowledgments

For their generous assistance in
preparing this book, I would like to
thank Janet Goleas, Giuliano and
Tina Gori, Diane Kelder, Phyllis
Tuchman, and, of course, Beverly.
—Barbara Rose

Contents

4 Art into Nature:

The Landscape Projects of
Beverly Pepper

Everything today reduces itself to
the essentials. If necessary, you can
reduce even a violent physical sensa-
tion to its essentials. The force of
new art lies in the power to give not
a diagram but rather an equation, if
my terms are exact, of what happens
in relationships These works . . .
represent a kind of silence, a word-
less one which is not finally mute.
They address themselves to people,
binding, bending, exalting them.
They present a revelation, the revela-
tion of poetry.
—Giuseppe Ungaretti,
letter to Beverly Pepper, 1968

Beverly Pepper is internationally renowned as an abstract sculptor; neverthe-less, her work has always been informed by the forms and forces of the natural world. Her outdoor environmental projects are not an assault on nature but a collaboration with the landscape. Their originality lies in her unique capacity to unify the three-dimensionality and conceptual content of contemporary sculpture with the environmental potential of landscape architecture. It is an achievement based on a lifelong dedication to developing and expanding her own personal esthetic, an immense curiosity about the various forms and styles of world art, and an understanding of the underlying universal principles common to all authentic expressions of the spiritual content of culture.

To understand the relationship between culture and nature in Pepper's work, it is necessary to distinguish between the two types of nature represented in Classical art: *natura naturans*, the untouched state of nature before the Fall, and *natura naturata*, the ordered and structured man-made gardens and fields that connote the civilizing goals of a humanistic culture. As art historian Barbara Novak points out, in 19th-century American painting, the prelapsarian virgin wilderness— *natura naturans*—is identified by pantheistic Transcendentalism as the awe-inspiring connection between the human and the divine. In the context of the closing of the frontier, intrusions into the virginal purity of the wilderness were perceived not as civilizing gestures but as base materialistic invasions.

Living much of her adult life in Italy, Pepper matured and developed in the world of Roman and Renaissance landscape with the idea that nature could be shaped, ordered, and civilized by man; nevertheless, the strain of New England Transcendentalism has deep roots in her consciousness. She wished to synthe-size the humanistic with the pantheistic views of nature to resolve her own dual allegiance to Renaissance humanism and American pantheism. Her turn away in the late 1960s from vertical and columnar structures, with their inevitable figural connotations, toward horizontal landscape environments—culminating in her landscape architecture projects in Spain, Italy, and Switzerland, examined in this volume—permitted her to integrate the European and American views of the role of nature in culture.

Pepper works empirically and pragmatically, a very American method. She does not start from any *a priori* theory or ideology, but by scribbling and sketch-ing automatically, the Surrealist method of tapping the unconscious that freed Americans from the rigid grid of Cubist geometry. Her development is intuitive rather than rational, felt rather than thought. She is drawn to the challenges of problem-solving; she sees each important work as an opportunity for personal and artistic growth. In the course of her quest for personal and artistic integration, her hegira carried her around the world to study firsthand the places that marked the rituals and spiritual totems of cultures other than our own. However, her need for lived experience rather than academic abstraction contributed to a nomadic life that marginalized her from group efforts and left her to develop in relative isolation.

In 1948, at the age of 24, Beverly Stoll was a successful budding artist with a top job as an art director in Manhattan. She had graduated from Pratt Institute and studied figure drawing at the Art Students League and art theory at Brooklyn College with the Hungarian kinetic art specialist, Gyorgy Kepes. Through Kepes, she became acquainted with interdisciplinary Bauhaus concepts concerning the union of art and architecture in an integrated, socially responsive whole. At the

time, the only artist thinking in this holistic manner was the Viennese Frederick Kiesler. His environmental *gesamtkunstwerke*, the *Endless House*, was virtually unknown until recently, but by chance Pepper had met Kiesler in New York and knew firsthand his radical environmental design concepts marrying sculpture and architecture.

In New York, she was successful but dissatisfied. Like the characters in Bertholt Brecht's opera *Mahagonny*, she felt about the postwar American cornucopia of plenty that "*etwas fehlt.*" She wanted to start over from scratch. Determined to see the treasures of Western art that had survived the war in Europe, in 1949 she sailed for France on the SS *De Grasse* with an appetite for adventure and esthetic and cultural experiences not available in America. Her first stop was Paris, which was still recovering from wartime destruction. There were few tourists, but a number of American artists had stayed on after the Liberation to study art on the G.I. Bill—for which she, as a woman, of course did not qualify. She devoured what she saw: She haunted the museums, visited the cathedral, castles, and the formal landscaped gardens of the ancien régime aristocracy like those of André Le Nôtre at Versailles.

During the day, she studied Cubist esthetics at the Académie de la Grande Chaumière with the noted Cubist painter André Lhote. She may have rubbed shoulders with a number of other Americans of her generation who were studying there, like Ellsworth Kelly, Robert Rauschenberg, Al Held, Julius Olitski and Jack Youngerman, but she does not remember meeting them. She also briefly studied with Fernand Léger, the great champion of outdoor public art.

This was the existentialists' *rive gauche* Paris: Jean-Paul Sartre could be seen at the Deux Magots with a glamorous, black-clad Simone de Beauvoir, who had not yet written *The Second Sex*, while Juliette Greco, the reigning queen of left-bank *vie de bohème*, sang torch songs in dark, smoky basement dives. It was a hopeful world of heroic personalities and big ideas celebrating the defeat of Hitler and Fascism. The revolutionary new ideas of de Gaulle's Minister of Culture André Malraux, regarding a global "museum without walls," were very much in the air. Malraux was the first to recognize that art-book reproduction and color slides made all of world culture, East and West, tribal and civilized, ancient and modern simultaneously available. It was a perception that would be increasingly important to the young American artist who had come to Europe to expand her horizons, helping her to evolve a conception of art as timeless, universal, and without frontiers.

Earlier, Hemingway's "lost generation" held that when they die, good Americans go to Paris. For artists and writers, the American Dream was not to move to the suburbs with all the modern conveniences that "progress" provided, but to visit the City of Light where pleasure, sensuality, and art are cultivated and refined rather than rejected, as they continued to be, in a still-puritanical postwar America. The great cosmopolitan metropolis of the first half of the century, Paris was still the magnet for expatriate artists in the immediate postwar period, soon to be supplanted, however, by New York in the next decade. Pablo Picasso, Alberto Giacometti, Constantin Brancusi, and other giants of the School of Paris were still alive and quite visible, both in the cafes of Montparnasse as well as in the art galleries and at the Musée d'Art Moderne. And ironically, despite French chauvinism but as a result of its colonial conquests, Paris was the place to see non-Western art, particularly African sculpture and Asian painting and sculpture.

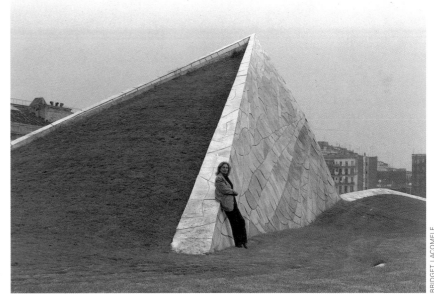

BRIDGET LACOMELE

Beverly Pepper, *Sol i Ombra Park*, Barcelona

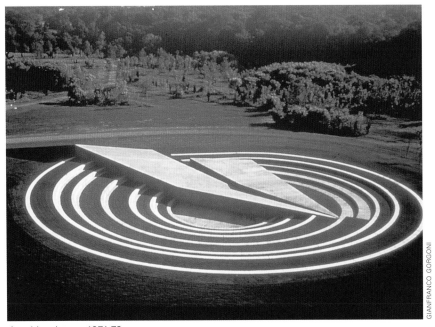

GIANFRANCO GORGONI

Amphisculpture, 1974-76
AT&T Long Lines Building, Bedminster, New Jersey
Concrete and ground cover

No one was more eager to look and to absorb what she saw than the young American artist. One day, on holiday in Rome, as she was crossing a hotel lobby, Beverly Stoll met Curtis Bill Pepper, an American author and journalist. Bill Pepper had served in Italy during World War II and had fallen in love with the country and its humane people. The promising artist and the writer were married in Paris a few months after they met.

In 1952, the young couple decided to move to Italy where it was less expensive to live and raise a family. Still suffering from wartime destruction, the Rome they settled in was the austere, gritty, still poverty-stricken city immortalized by the great Italian neorealist director Federico Fellini, who became their friend. Rome offered Beverly Pepper a variety of artistic stimuli in the form of its ancient ruins like the Coliseum and Circus Maximus—whose circular seating forms are recalled in her latest landscape architecture projects, as are the columns of the Roman forum and the huge, arching vaults of the public baths in the Roman hills. The colossal scale of imperial Rome made a lasting impression on Pepper. No less significant to her future art were the Renaissance and Baroque monuments, such as Bernini's fountains in the Piazza Navona and the fantasy landscapes of the Boboli Gardens. These were the images that Pepper absorbed to the degree that they became part of her thinking, and that continue to inform her beliefs about the relationship between man-made art and nature.

Pepper has always been quick to improvise and to invent; the creativity of the Italians forced to do much with little was both stimulating and familiar to her. Trained as a painter rather than a sculptor, she felt a need as a young artist to totalize experience and to express herself in solid, three-dimensional form. Her first sculptures are already large in scale: big swelling wooden volumes carved from a grove of trees she found cut down around her villa on Rome's Monte Mario. It was there that she made her first welded metal sculptures. They fuse the materials of nature with the iron of man in a way that prefigures the land art projects she began to conceive later in the 1960s. The wood sculptures are carved directly, their forms found rather than imposed a priori. This process, too, would characterize her mature work, as would the ambition not to emulate nature but to be a partner in its formation.

At first, she painted in an impastoed, gestural, figurative style that gradually became increasingly abstract. Her gestures were large, expansive, and physical. Seized by an urge to experiment—still her driving force—she started making large carved wood pieces. The forms were related to Henry Moore's organic shapes, but they were wilder, cruder, and more savage than Moore's reclining nudes and maternities. They already owed more to landscape than to the figure.

In 1962, the Peppers bought an old, crumbling property in the center of town in Rome's Trastevere, an equivalent of the *rive gauche*, where Pepper could have a studio. Because the house was assembled from different tenements, which she combined and restored, there were a number of terraces. Pepper quickly turned these into gardens with the help of her friend Daniel Berger, who kept a greenhouse where she liked to browse.

Pepper was drawn to the ritual mysteries of non-Western art. In 1960, she traveled to Japan and Cambodia. She had read Malraux's great existentialist novel *Man's Hope*, which documents the heroic struggle of Indochina to be free of French colonialism. Pepper's conception of women not as the antagonists of men but as

their copartisans owes a great deal not only to her political-activist mother and grandmother but to the images of heroic women drawn by Malraux, Jean-Paul Sartre, Albert Camus, and even Samuel Beckett, all of whom had worked with women in the Resistance. It was a concept entirely alien to the dominant 1950s American view, which was closer to Hitler's demand that women be confined to *Kinder, Küche, und Kirche*.

In Japan, she was particularly impressed by the gravity and serenity of Japanese Haniwa funerary sculpture, but the great Khmer temple complex hidden in the Cambodian jungle at Angkor Wat was a turning point for her art. Overwhelmed by seeing the interpenetration of the lush jungle with the mysterious Buddhist stone carving, Pepper had an epiphany: She must do sculpture which, at its most meaningful, would be not an object but an environment. It was an experience that lives with her even today and to which she often refers. On her return to Rome, she tried to capture the writhing energy of Angkor Wat in large, carved wooden organic sculptures that incorporate cast bronze and steel elements possessing both detail and texture. The hollows and voids of these organic, biomorphic shapes, some suspended in space, are reminiscent of Henry Moore; indeed they were first appreciated by Moore's greatest critic, Herbert Read, who exhibited one titled *Laocoön* in an exhibition he organized in 1961.

The monumentality and originality of her initial sculptural essays impressed the leading Italian critic of the moment, Giovanni Carandente, who invited Pepper to participate as one of ten sculptors in the outdoor exhibition in the public piazzas of Spoleto in 1962. Pepper had already gained the support of the great Italian critic and historian of Modernism, Lionello Venturi, as well as of the noted Italian architectural historian Giulio Carlo Argan. Now she had an opportunity to expand her possibilities and to grow as an artist as a result of Carandente's acknowledgment. Spoleto was the medieval Umbrian hill town chosen by composer Gian Carlo Menotti as the site of the "Festival dei due Mondi," where an unusual mix of theater, music, and art became a world-famous annual summer attraction.

With the cooperation of the Italian steel industry, Italsider, Carandente placed the internationally known sculptors in factories around Italy to realize large-scale works for the first important exhibition of public sculpture since the fall of Fascism. As Pepper has noted, at the time the idea of public art still smacked of authoritarian politics, which were anathema to the avant-garde. However, she was pleased to be one of three Americans invited—the other two were Alexander Calder and David Smith—and excited by the possibility of learning industrial welding techniques. For while Rosie the Riveter was fine for wartime weapons production, nobody was inviting women into American factories to make heroic-scale sculpture.

Pepper spoke fluent Italian, which certainly helped her to gain the confidence and cooperation of the factory workers in Piombino where she produced five large steel pieces—her first public sculptures—and seventeen smaller ones that constituted her first New York show of sculpture in 1963. The Spoleto "Sculpture in the City" exhibition was a success, and has since been widely copied throughout Europe. During this time, she saw a lot of David Smith, who often needed her to translate while working in the Voltri factory whose name appears in the title of the famous series of works he finished later in his Bolton Landing studio. She believes the turning point for public sculpture—shunned by contemporary artists as a propaganda for official political values they did not share—was the success of Smith's large-scale works in Spoleto, as well as Calder's 40-foot-high sculpture at the Spoleto train station.

Her relationship with Smith was vital to her development; it was rich and complex as both a human and artistic interchange. For example, when the architect William Lescaze wanted Smith to make a sculpture for a new building he was designing in New York in 1962, Smith declined because he did not work on the architectonic scale of the skyscraper. However, he was so impressed by Pepper's Spoleto sculptures he suggested Pepper to Lescaze. She was 38 years old, and her only previous experience in factory fabrication had been collaborating with the workers in Piombino to make her large-scale pieces for Spoleto.

Pepper considered the challenge daunting, yet, with Smith's encouragement, she accepted her first architectural commission. The 18-foot-high construction made of 1-inch-thick stainless steel that stands in front of the Marine Midland Bank building in midtown Manhattan is one of the very first outdoor abstract sculptures in America. A now-familiar landmark, its thick linked rings, which hang freely in space, were made in the Waterbury, Connecticut, factory where Calder fabricated his mobiles and stabiles. She was shocked to discover that Calder's works were blown up from 6-inch cardboard maquettes rather than realized actual scale, as she worked. Indeed, the whole notion of the maquette, central to public art, was new to her. Throughout her life, although she initially makes models, she has always worked on them in full scale.

A generation younger than David Smith, who was both a friend and an encouraging supporter, Pepper was not happy at the time with either the figurative basis or the flat planar construction of contemporary sculpture derived from Cubist collage, which projected the shapes of painting into the literal space beyond the picture plane. She had been trained as a painter, but as a sculptor she was self-taught. She always preferred Picasso's later solid-cast bronzes to his Cubist assemblages. She admired primitive, Asian, and Roman Baroque art. Her origins were not flat planes but massive volumes; she was inspired by the classical oppositions of hollow and void and the solidity of in-the-round mass that separates painting from sculpture.

In Paris, Pepper saw not only Constantin Brancusi's monolithic volumes but also the few rare pieces of Marcel Duchamp's brother, the sculptor Raymond Duchamp-Villon, who had begun to invent a Modernist version of foundry-cast sculpture that was neither planimetric nor pictorial when he died on the eve of World War I. Like Brancusi, Duchamp-Villon simplified and streamlined volumes, but he also integrated the movement and torque of *contrapposto*, forcing the viewer to see the work in the round as a dynamic physical experience related to the body—an experience that the conceptual purity of Brancusi's symmetrical, static hieratic forms denies. In this sense, Duchamp-Villon, who worked in plaster and cast bronze, represents the last flowering of the Western secular tradition of sculpture. The Romanian Brancusi, who carved wood and stone, made altars and shrines that are, in their solemnity and archaic simplifications, implicitly dedicated to the worship of the Apollonian god of esthetics. As much as Pepper was deeply involved in the vital and organic processes of life and of the body, she felt closer to Brancusi's archaic simplification.

The death of David Smith in an auto accident in 1965 left a great void at the center of American sculpture. Of the sculptors of the younger generation, only Mark di Suvero was making work that, like Pepper's, came out of a tradition of sculpture rather than out of a literalist reaction to the illusionism of painting, as did Minimal art. Only in the mid-1970s did di Suvero find a factory in France in Chalon-sur-Sâone where he could make architectural-scale sculpture with the aid of industrial tools. Like di Suvero and Smith himself, Pepper was suspicious of fabrication and of the mechanical and essentially reproductive process of blowing up and enlarging large-scale sculpture from tiny maquettes. To combine human scale and touch using factory methods, each ultimately acquired the necessary tools to turn her or his studio into a one-person factory. This permitted them to realize outdoor public sculpture on a large scale with new materials without sacrificing their intimate relationships with the work by turning it over to others for fabrication. Smith, Pepper, and di Suvero also had in common that they knew how to cast bronze, the traditional technique for sculpture since antiquity, which Modern sculptors had rejected for industrial assemblage.

The art and technology movement in the United States gave new impetus to environmental art, which required a new, state-of-the-art technology. In this context, David Smith's friend and contemporary, the architect Tony Smith, was finally able at the end of his life to make large-scale volumetric public sculpture. In fact, Tony Smith's works may have made a greater impression on Pepper than David Smith's figure-based vertical constructions because, like architecture, they claim the environment. In any event, it is clear that Pepper's sculpture has almost nothing in common with that of her American contemporaries, the second generation Abstract Expressionists who were still struggling with the lumpy expressionism of Jacques Lipchitz.

The geometry of her polished marble and mirror-surface stainless steel works of the late 1960s certainly owes something to the geometric rigor of David Smith's late *Cubi* constructions. Their preoccupation with the reflective surfaces recalls Smith's use of scored stainless in the late *Cubi* series, but their intention and their transparent, open forms are significantly different. Like Pepper's works in general, the highly polished pieces are interactive and illusionistic, informed by a phenomenological vision that also distinguishes Anthony Caro's horizontality from David Smith's opaque verticality. In Pepper's mirrored stainless sculptures, reflectiveness is not decorative surface design, it has a specific purpose: to mirror and thus incorporate the landscape, grass, and sky in a way that prefigures her use of grass in the 1970s and the ceramics of her Barcelona park begun in 1987.

In 1972, the Peppers decided to abandon the *dolce vita* of an increasingly urban and congested Rome for an isolated ancient castle in rural Umbria, where she found another opportunity to exercise her passion for architectural restoration. Her experience with the interior volumes of the giant masonry walls and vaults surely informs the sense of the "built" that is an important part of all her land artworks.

Pepper knew about Minimal art and the earthworks that evolved out of it in the late 1960s, but she perceived them as essentially negative critiques of gallery and museum art rather than positive approaches to environmental landscape structure. Robert Smithson's paeans to Olmsted's Central Park as the natural antidote to the industrial horrors of New Jersey were not as fascinating to her as

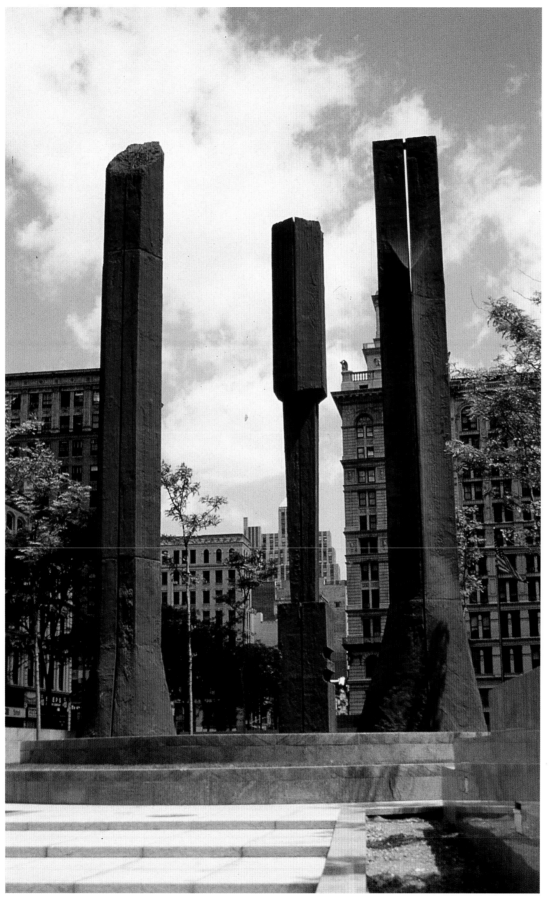

Manhattan Sentinels, 1993-96, New York; cast iron

moving the earth and creating the landscape in the "green heart of Italy," as the province of Umbria where she lives is known.

She had been preoccupied with the environmental context of sculpture since her visit to the Far East in 1960. In the late 1960s, she began experimenting with grass, hay, and sand as containers for sculpture. Increasingly isolated in Italy, where the avant-garde was characterized by neo-Duchampian Arte Povera, she did not find Piero Manzoni's canned excrement compelling. It was never her interest to shock but to awe the public. But the mammoth American intrusions into the landscape, like Michael Heizer's *Double Negative*, a huge depression incised like a scar into the desert, linked up to themes that had preoccupied her since confronting the mystery of Angkor Wat.

In her Umbrian studio, she began sketching and making maquettes for immense visionary landscape sculpture that at the time had no patrons to finance them. She did not know Virginia Dwan, the mining heiress who financed the first earthworks, not until she met the Florentine Maecenas Giuliano Gori, a brilliant and cultivated textile broker like his Renaissance namesake Giuliano de' Medici, was she able to put many of these ideas into practice. Appropriately, the early visionary projects will be shown at an exhibition at Gori's outdoor sculpture park, the Villa Celle, site of Pepper's cast-iron amphitheater (pages 52-55), in 1998, coinciding with her retrospective at the Forte Belvedere in Florence.

Estranged from the *épater le bourgeois* shenanigans of the Italian avant-garde, Pepper began to spend more time in the United States concentrating on public sculpture. In 1971, she was commissioned by the city of Boston, which had received a National Endowment for the Arts matching grant, to make her first state-commissioned piece, the dramatically cantilevered *Sudden Presence*. For the Boston commission, she used Cor-ten, a new industrial material that takes on a rusted patina once it is exposed to the sun. She was one of the first to experiment with it in 1964 while working at the U.S. Steel mill in Pennsylvania. Her first work in the material was the 1965 *Cor-ten Viewpoint* for collector Jan Cowles' hilltop house in Westchester, New York.

Pepper used Cor-ten throughout the 1970s because, like bronze, it had its own intrinsic color without being painted. She was fascinated by the way the patina of Cor-ten changed through exposure to the sun, giving it a velvety painterly surface and soft edges. The artist Barnett Newman asked her for advice on quickening the rusting process, which gave an eroded, timeless quality to the work. However, as Pepper found out, the material could also seriously corrode, making it nearly impossible to maintain. Learning this, she began a search for a more resistant material.

In 1976, she found a set of molds for factory tools in a junkyard outside of Todi, near her home in Umbria. The tools inspired her to forge small steel works and experiment with casting iron. She began to make sculpture that recalls, in a self-reflexive manner, the tool forms which are the origin of her series of *Sentinels*. In 1979, she honed her knowledge of cast iron while working on the *Moline Markers* at the John Deere factory in Moline, Illinois. The new material ductile iron gave many of the qualities of color and surface of Cor-ten, plus the tensile strength of steel with the added advantage of being impervious to time.

In her studio, she began projecting a horizontal sand-dune piece that eventually turned into her first earthwork, the *Dallas Land Canal and Hillside*. She continued her explorations of the landscape environment in 1974-76 in the Bedminster, New Jersey, site project *Amphisculpture*, whose downward sloping, ringed seating area is echoed later in *Teatro Celle*.

Pepper had already imbued her stainless steel pieces of the late 1960s with the sense of movement, intrinsic to the excitement of traditional sculpture that relates to the body. They tumbled, opened, and closed like an accordion or a fan. Indeed, the title of one of the most graceful is *Ventaglia*, Italian for "fan." In works of the early 1970s, like the stainless steel *Exodus*, the cantilevering would become ever more precarious and complex to engineer. In the late 1970s, Pepper began shuttling between America and Italy at a frantic pace, working alternately on both continents. In 1979, four monumental sculptures from more than 28 to more than 35 feet high were set up in the piazza of Todi. Both fabricated and cast in carbon steel in the local Terni steel mill, the Todi columns were more site-specific than it may have seemed since they were inspired specifically by Todi's magnificent medieval piazza and created on an architectural scale reminiscent of the medieval fortress towers like those of San Gimignano in Tuscany. Her experiments in ductile iron at the John Deere farm machinery factory had given her new possibilities for large-scale totemlike works like the towering Todi columns.

Pepper's growing interest in environmental projects inevitably pushed her in the direction of earthworks, but once again, she kept a distance and remained outside of any movement. In 1979, she worked on a Seattle land reclamation project with artists like Robert Morris and Dennis Oppenheim; in the 1980s, all three would complete important commissions for Gori's Villa Celle. The land reclamation projects made popular by the ecological movement in the United States permitted a number of American artists to experiment with "user-friendly" sculpture, that is, art engaged with solving environmental problems as opposed to decorating museums with objects. As earthworks evolved into land art, ecological sensitivity became a central issue, as it had been for Pepper throughout her life.

Sol i Ombra
Barcelona, Spain
1987-92

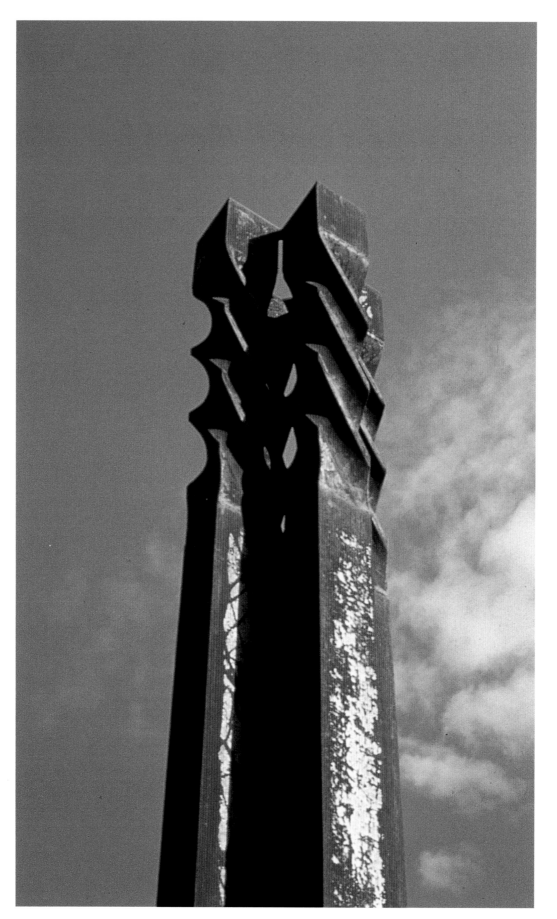

Cast-iron entry columns

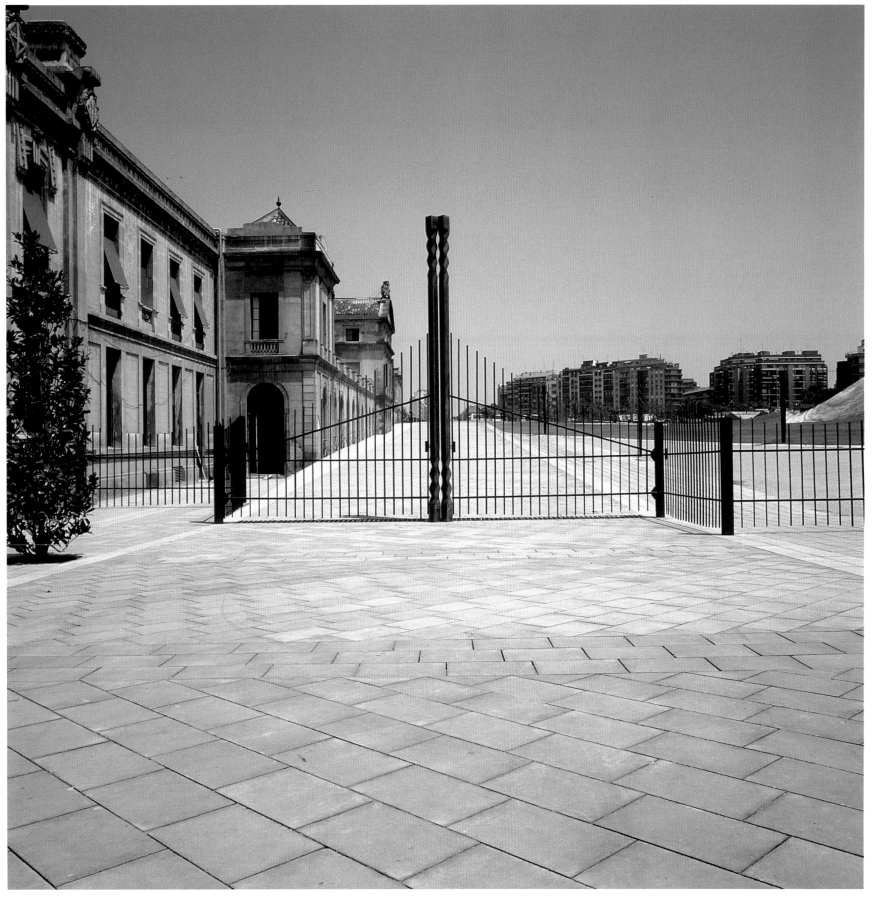

West entry gates

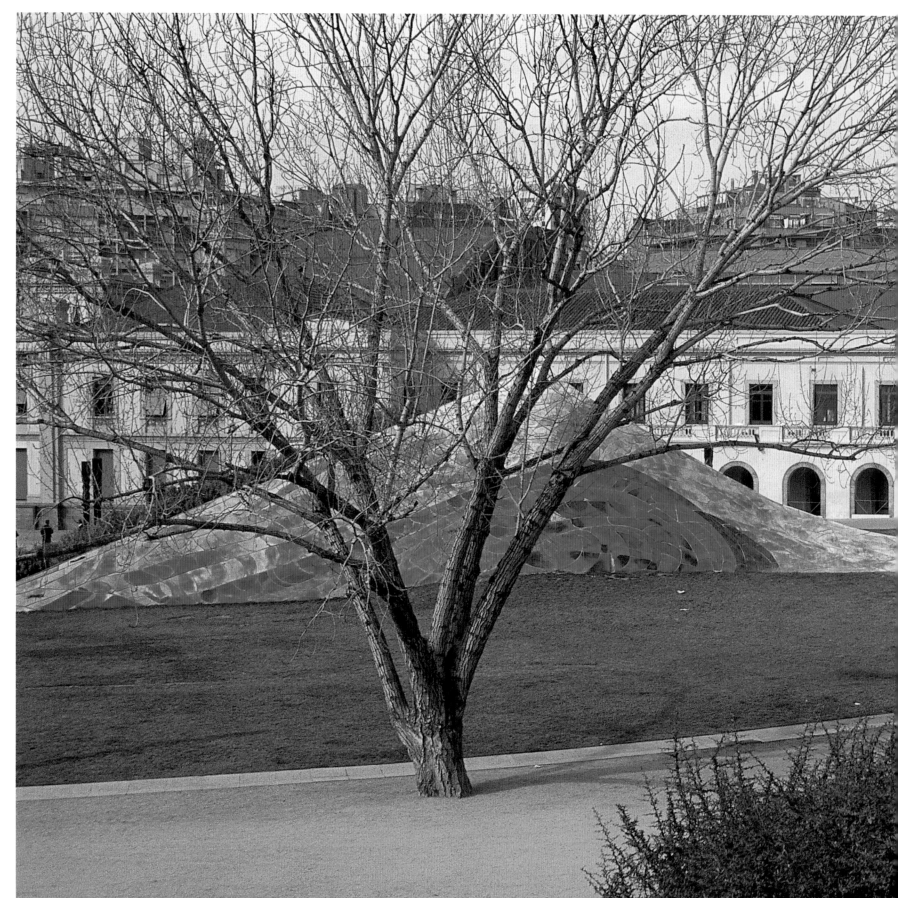

Southern face of *Cel Caigut* with Estacio del Nord in background

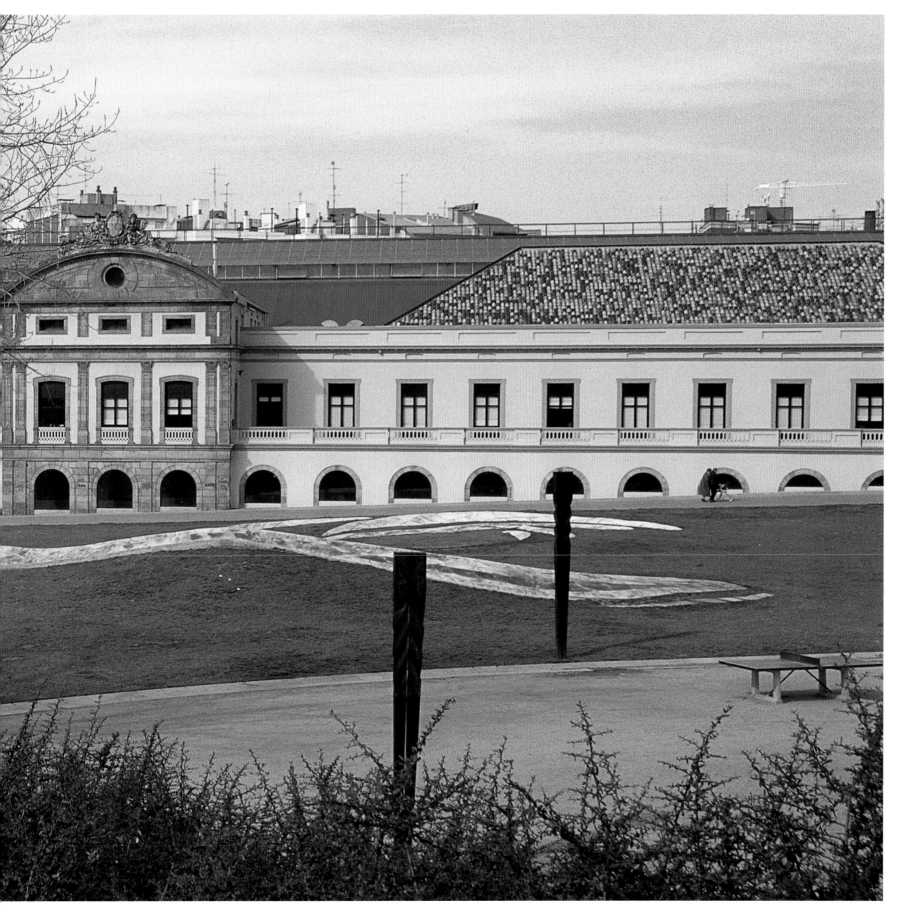

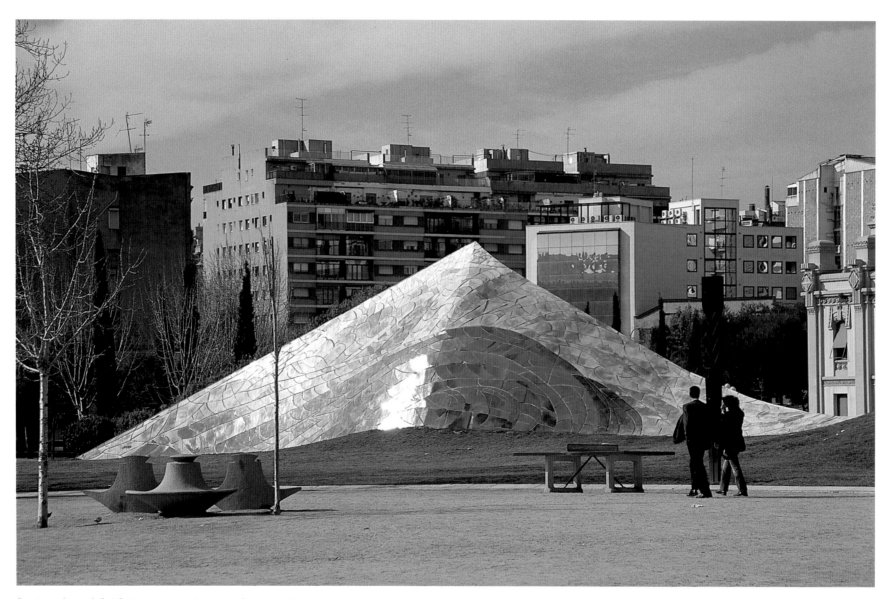

Southern face of *Cel Caigut*; concrete benches (foreground)

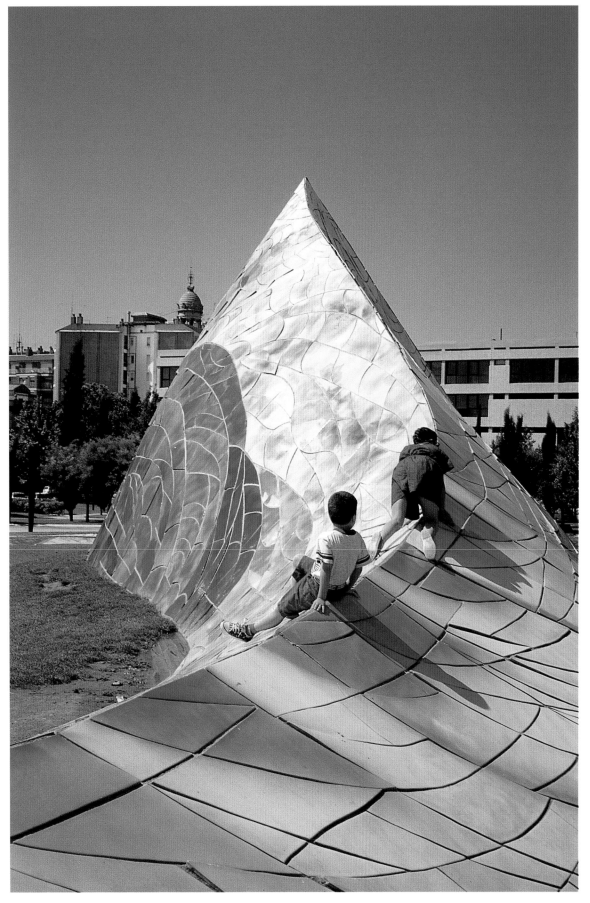

Detail of *Cel Caigut*, eastern face

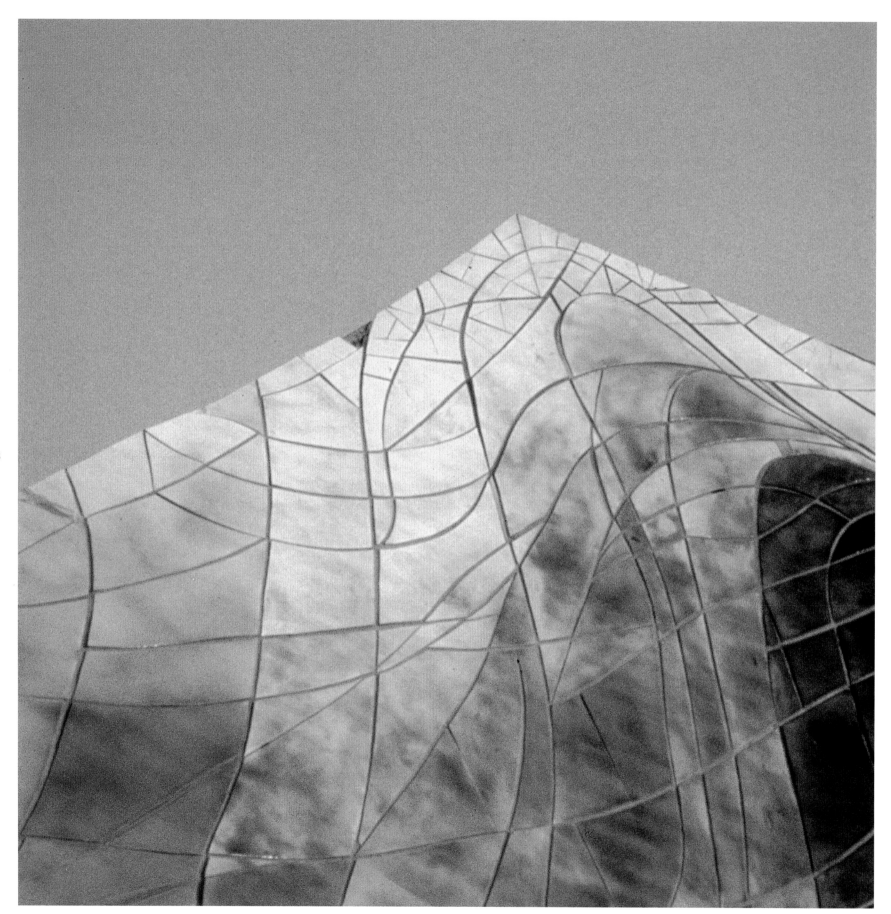

Detail of *Cel Caigut* ceramic tiles showing linear spacing

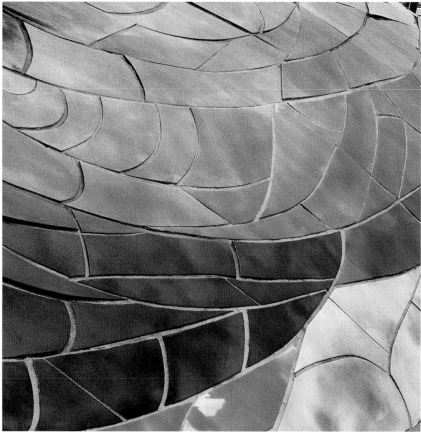

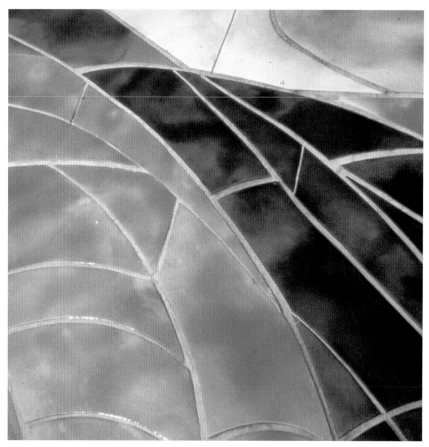

Details of ceramic tiles

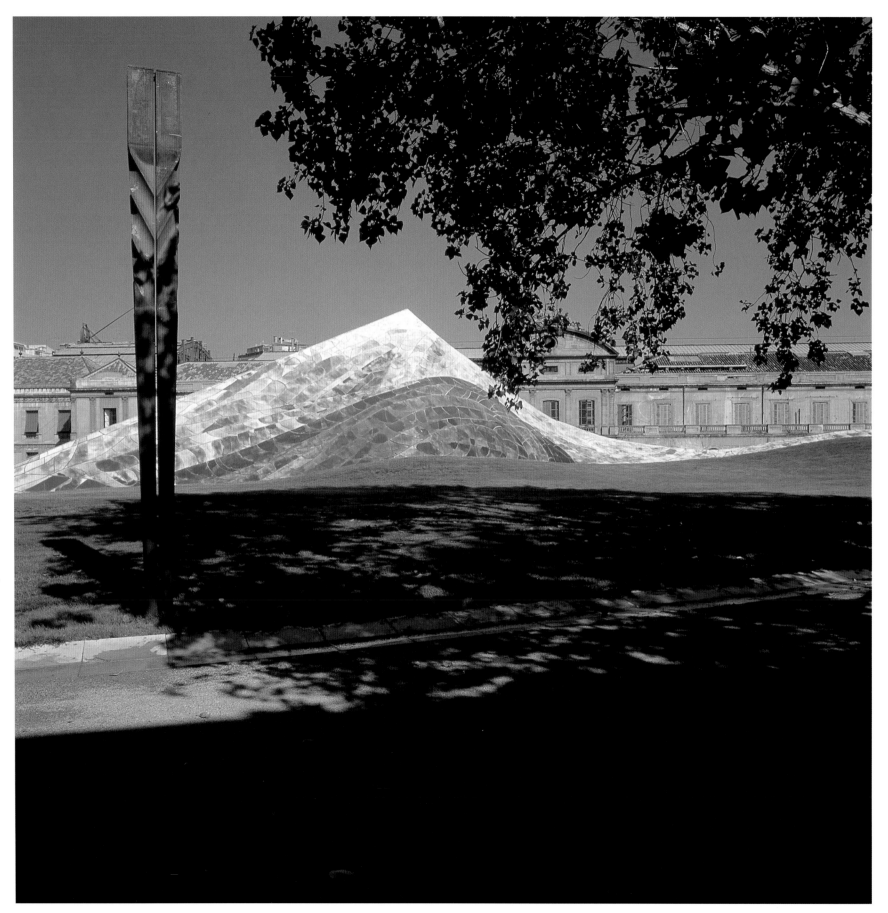

20

Fifteen-foot-high cast-iron lighting element (foreground)

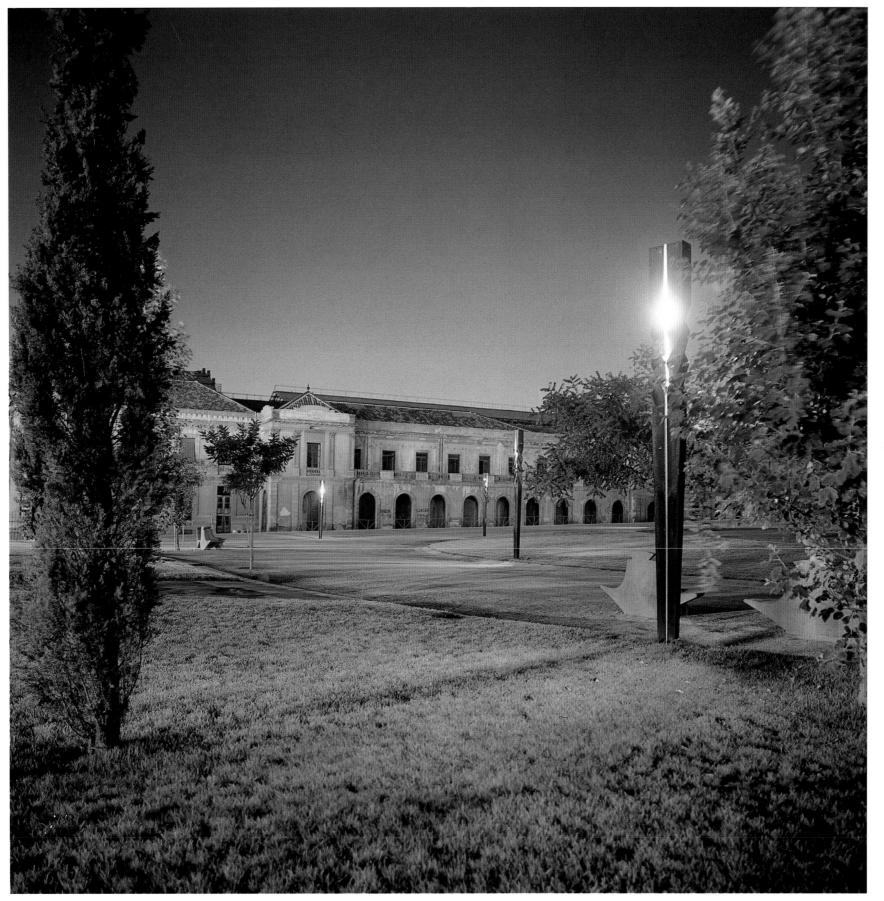

Nighttime view of *Sol i Ombra Park* with illuminated lighting elements

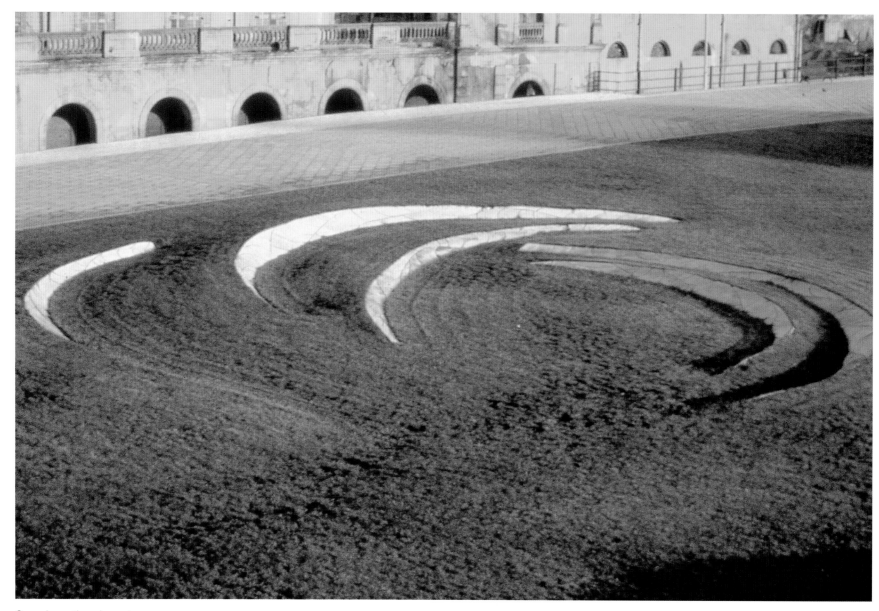

Ceramic seating elements

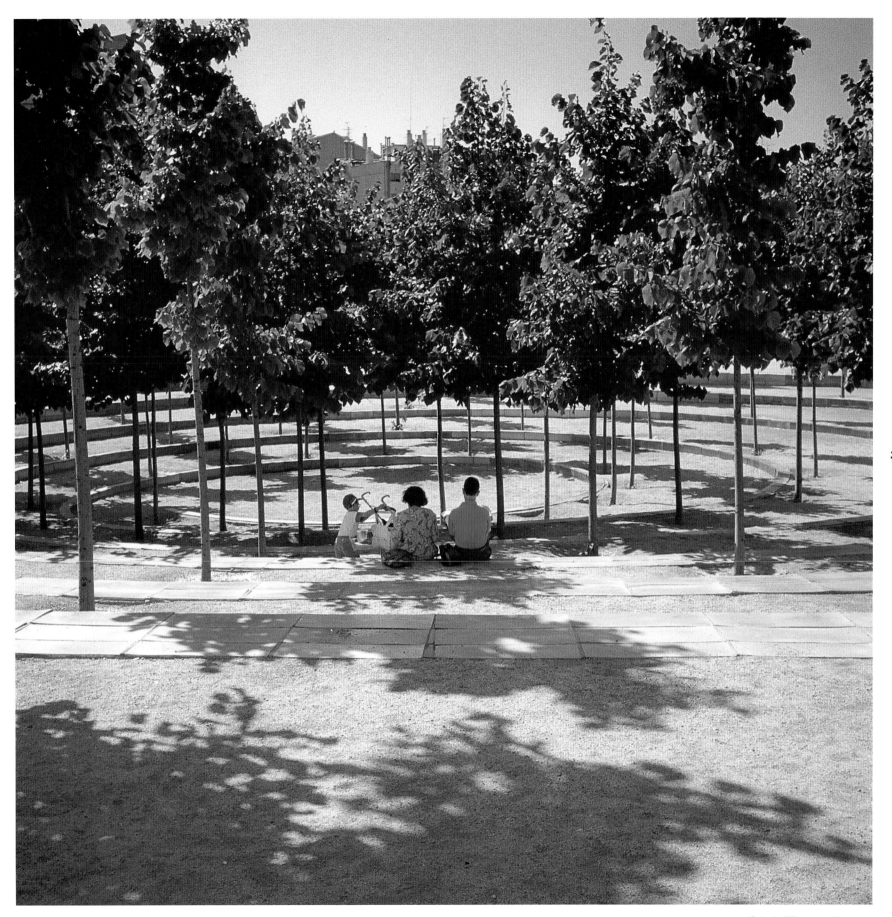

Spiral of Trees seating area

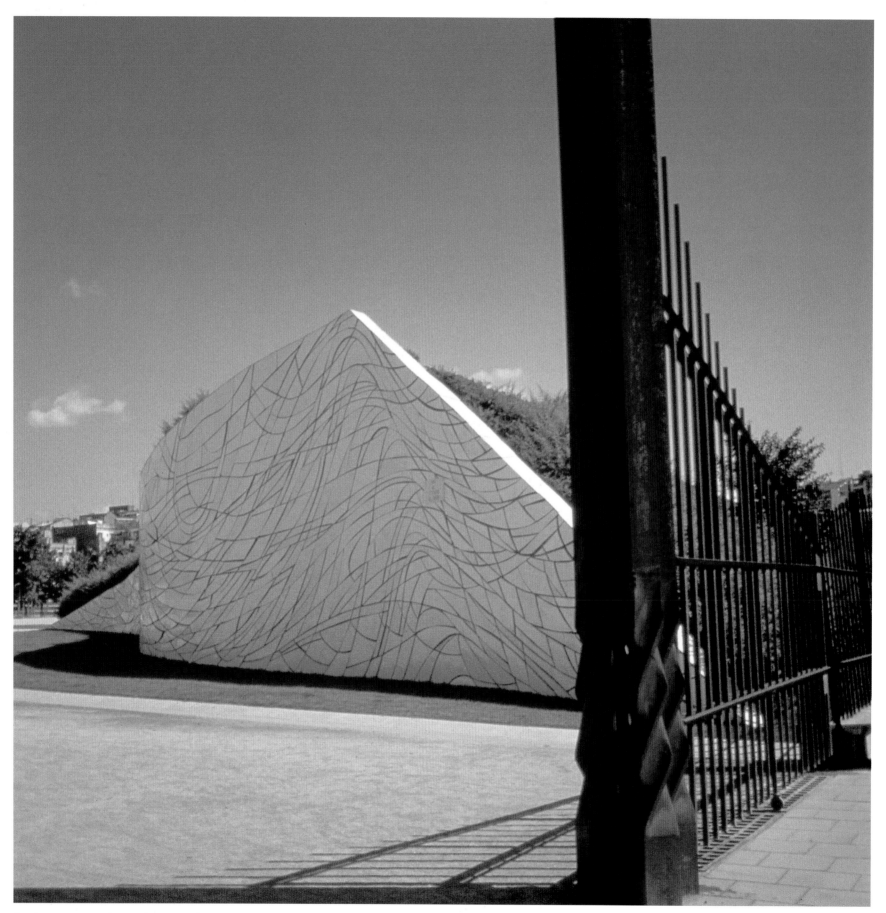

24

South entry gate and ceramic entry wall

Teatro Celle
Pistoia, Italy
1989-91

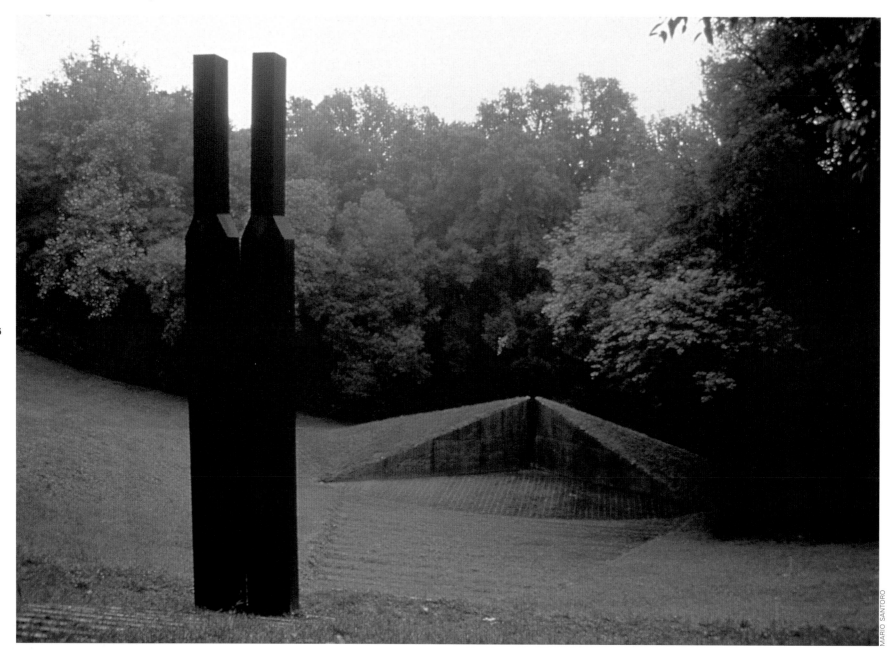

Overview of *Teatro Celle* showing *Precursor Sentinels* (foreground) and *Filiate Walls*

MARIO SANTORO

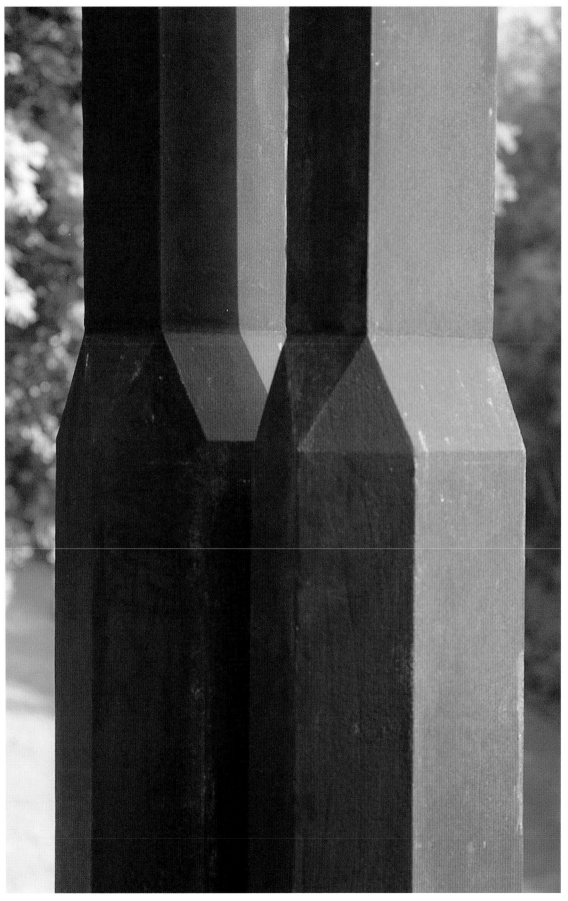

Detail of *Precursor Sentinels*

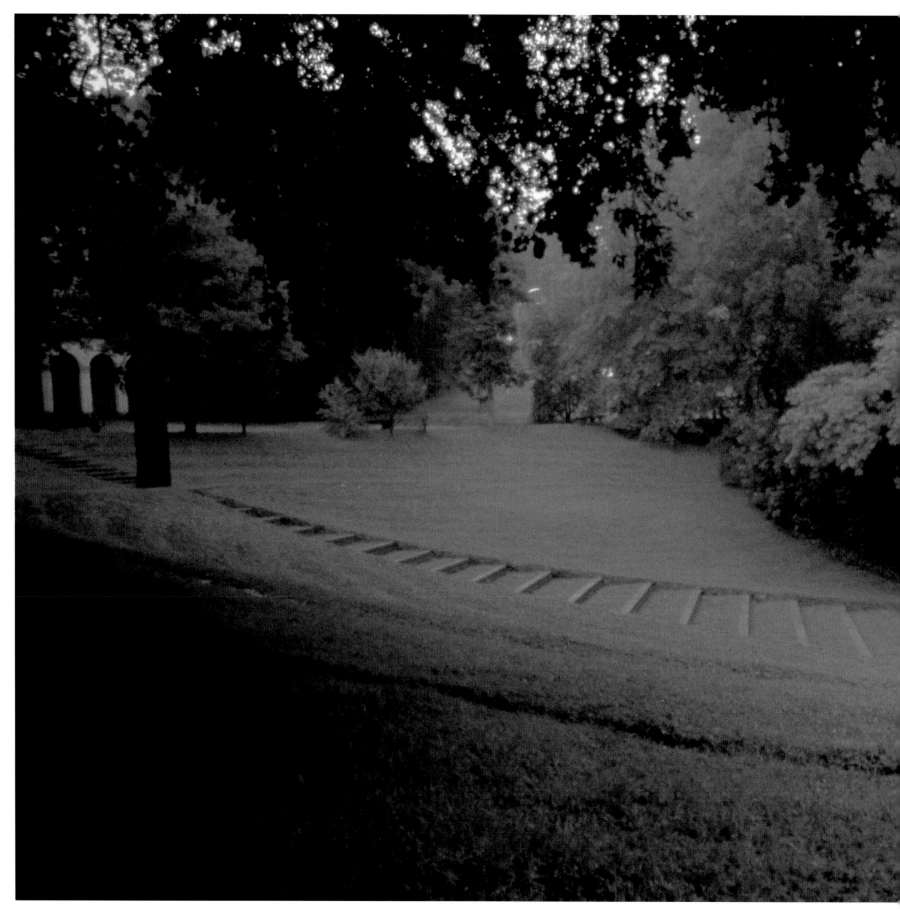

Teatro Celle, as viewed from woods

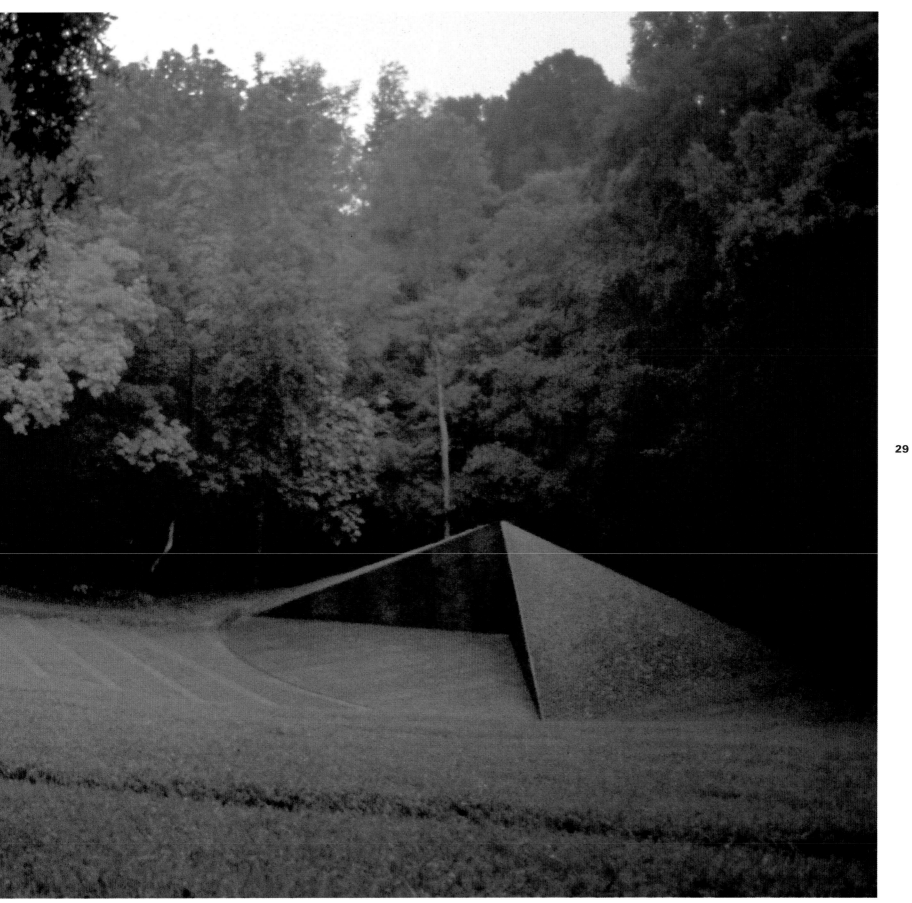

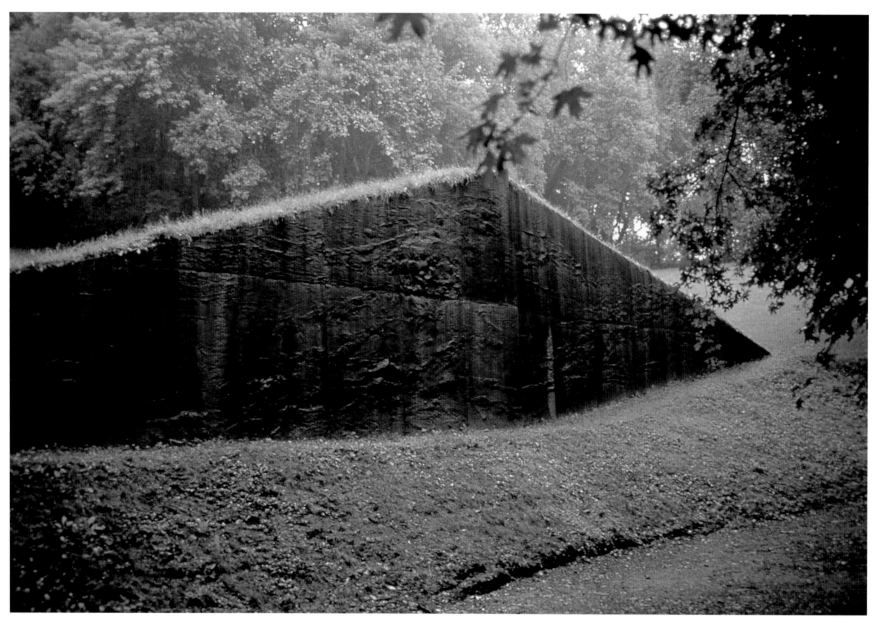

Filiate Walls

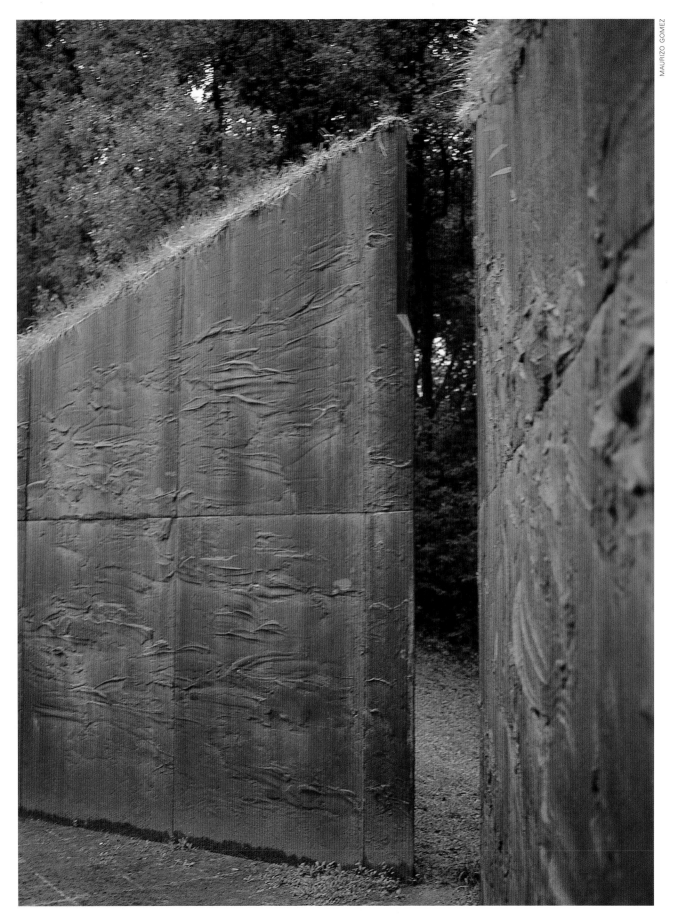

31

Detail of opening in *Filiate Walls*

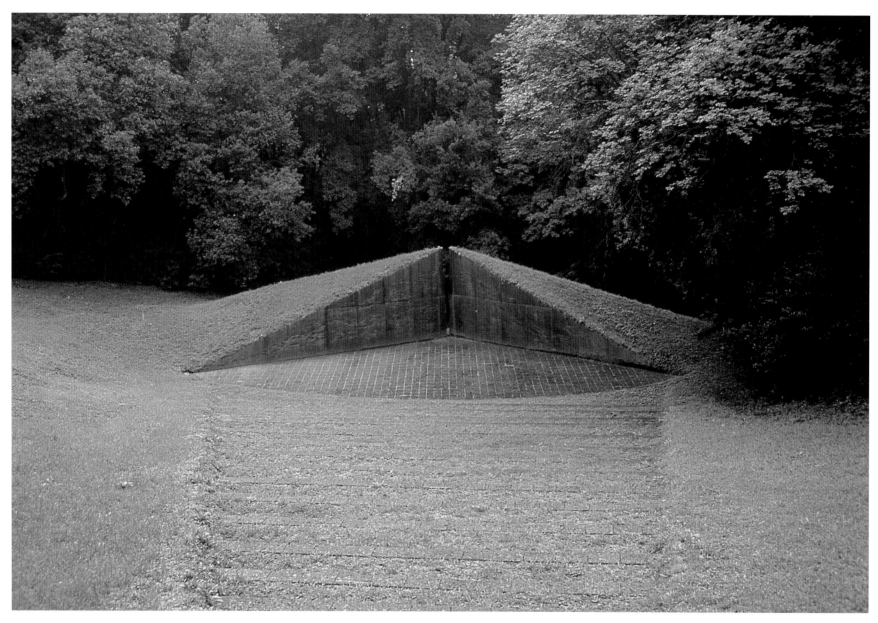

View of proscenium in *Filiate Walls*

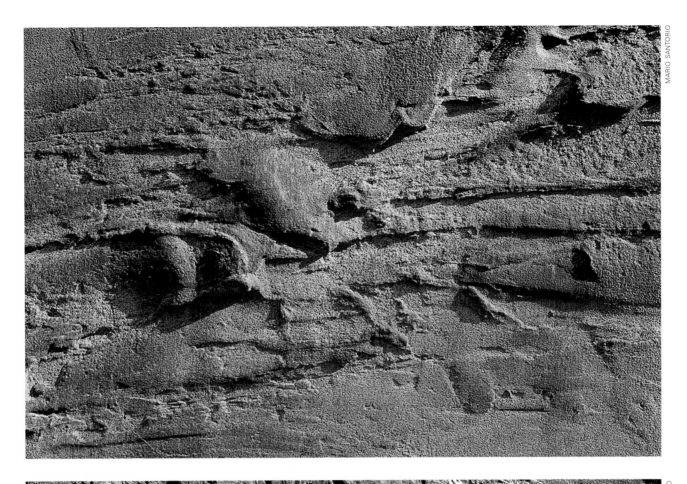

33

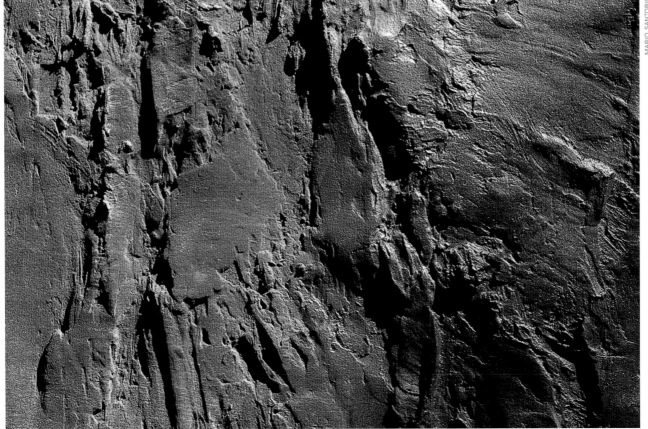

Details of cast iron texture

Filiate Walls illuminated during nighttime performance

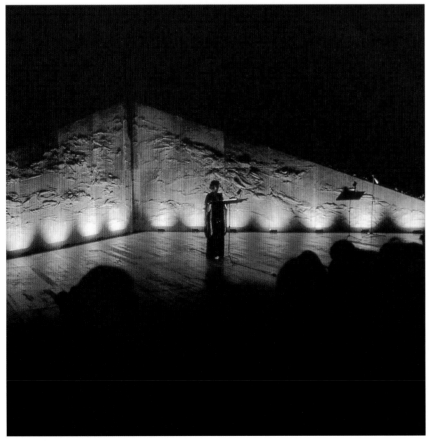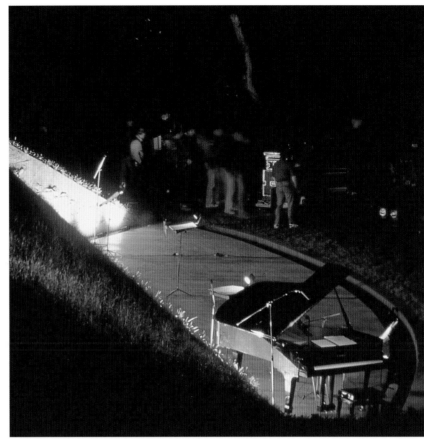

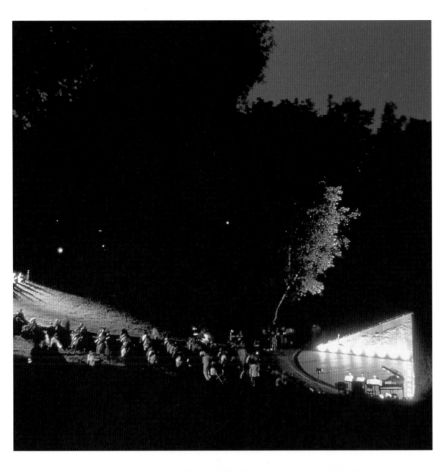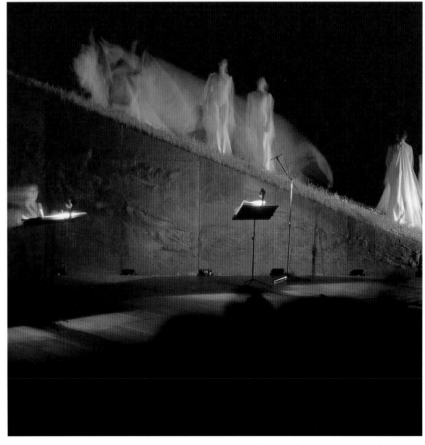

Details of stage during performance

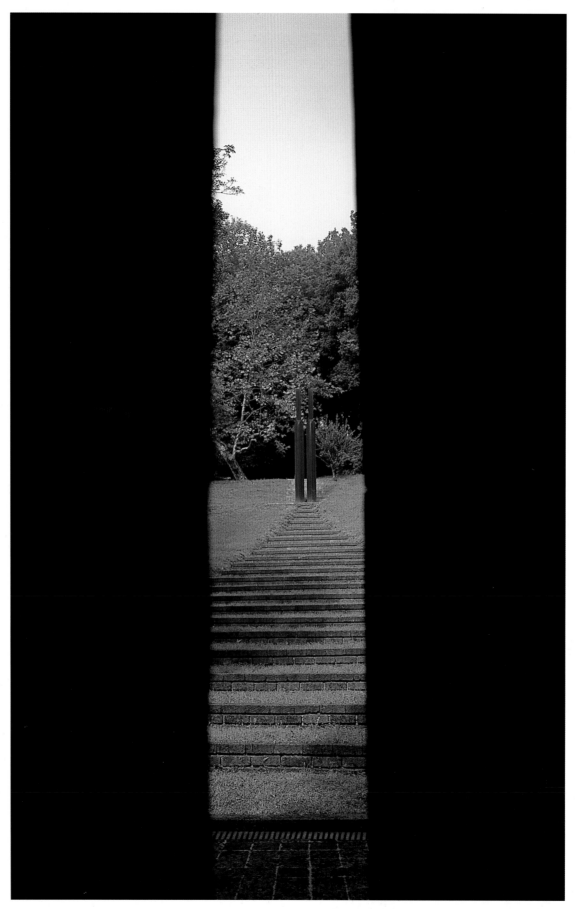

View from woods through *Filiate Walls*, looking over seating toward *Precursor Sentinels*

Palingenesis
Zurich, Switzerland
1993-94

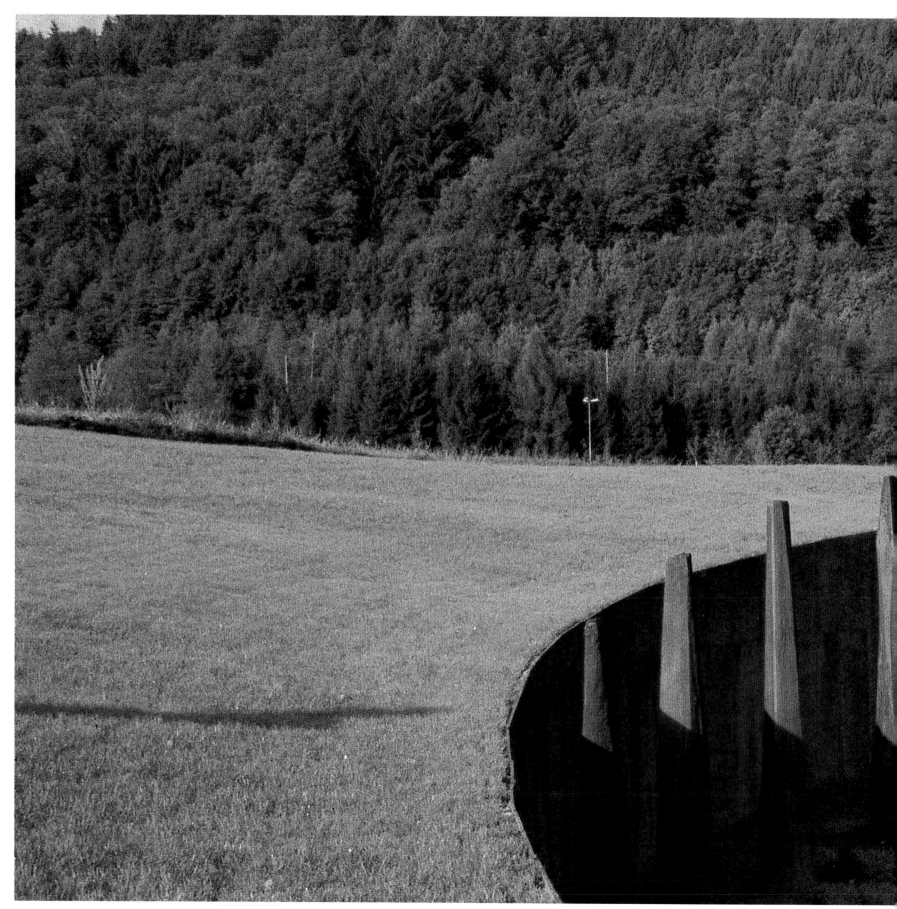

View from above

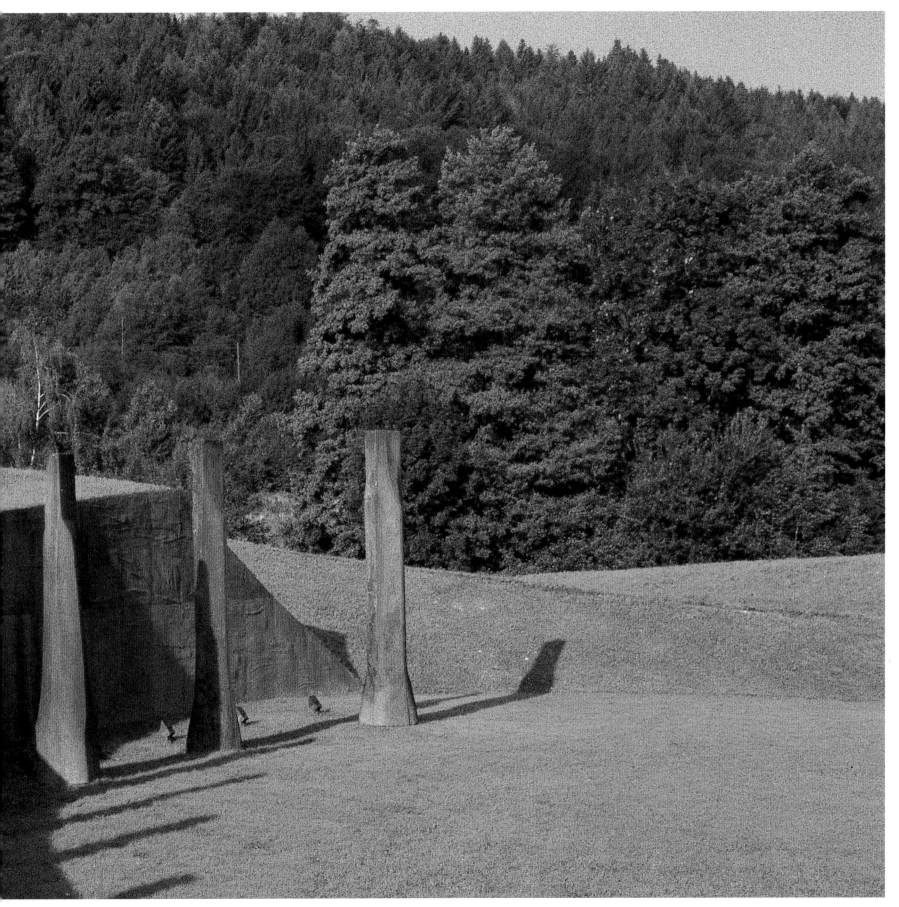

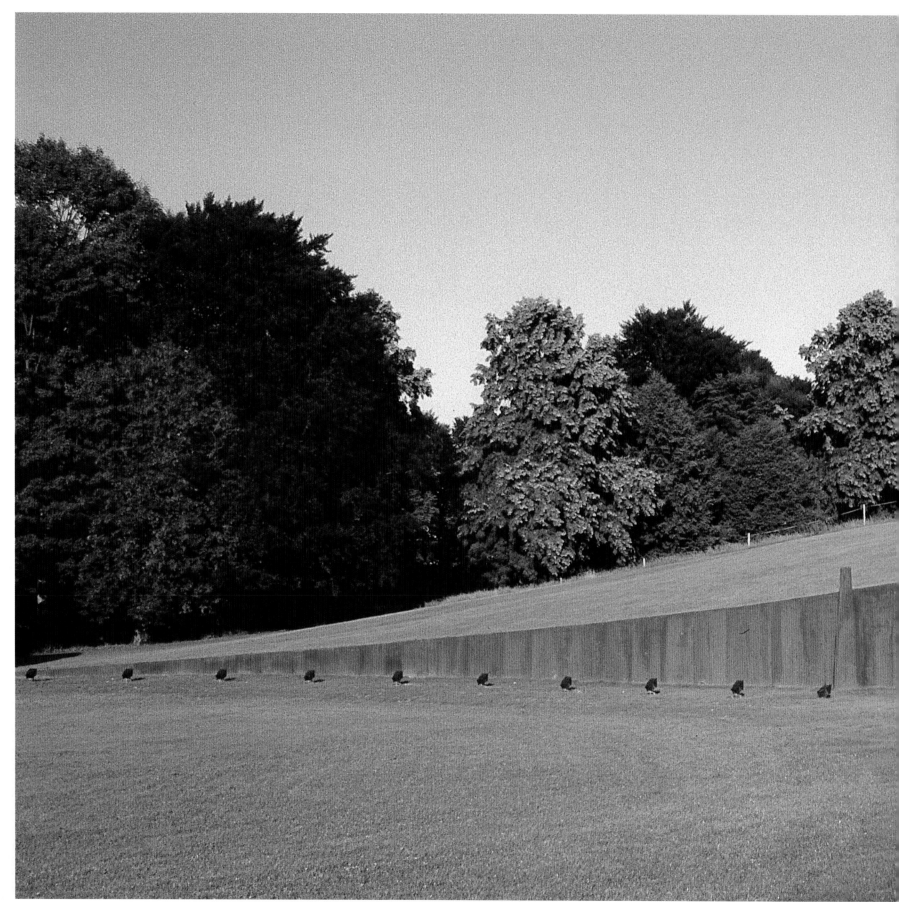

Overview of *Palingenesis*

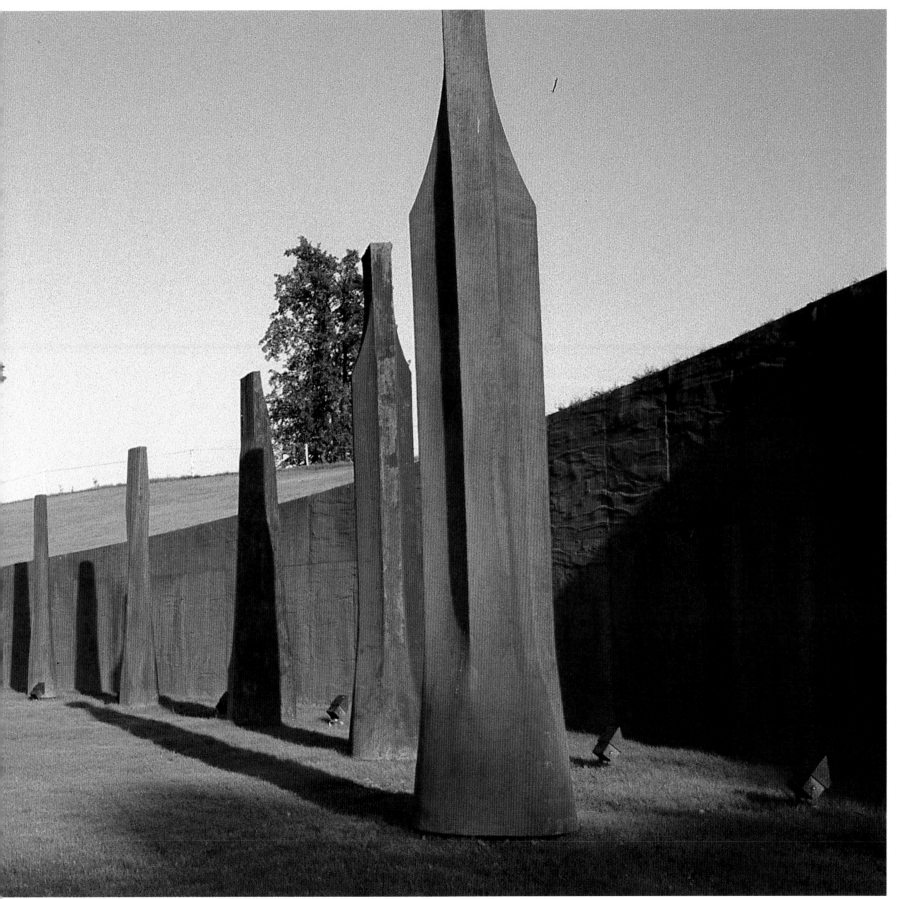

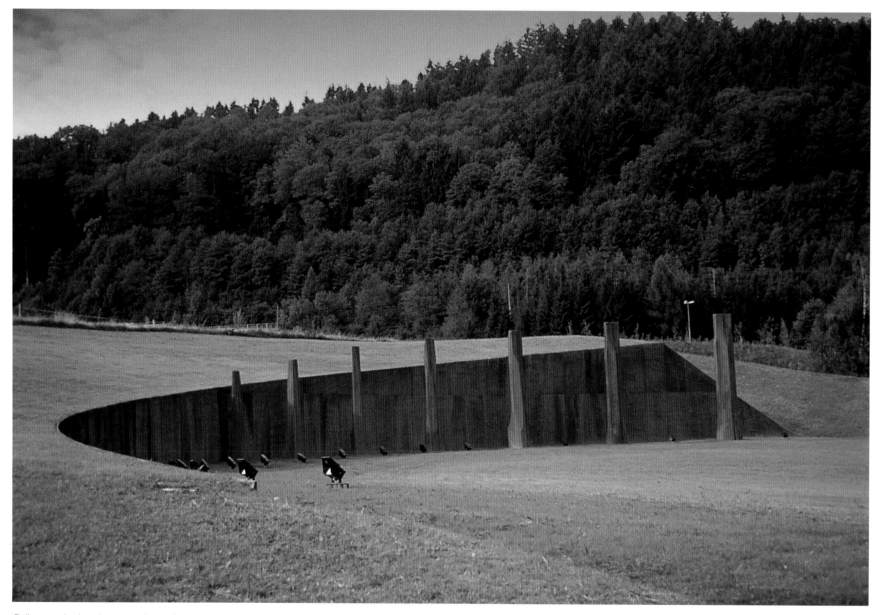

Palingenesis showing emerging columns

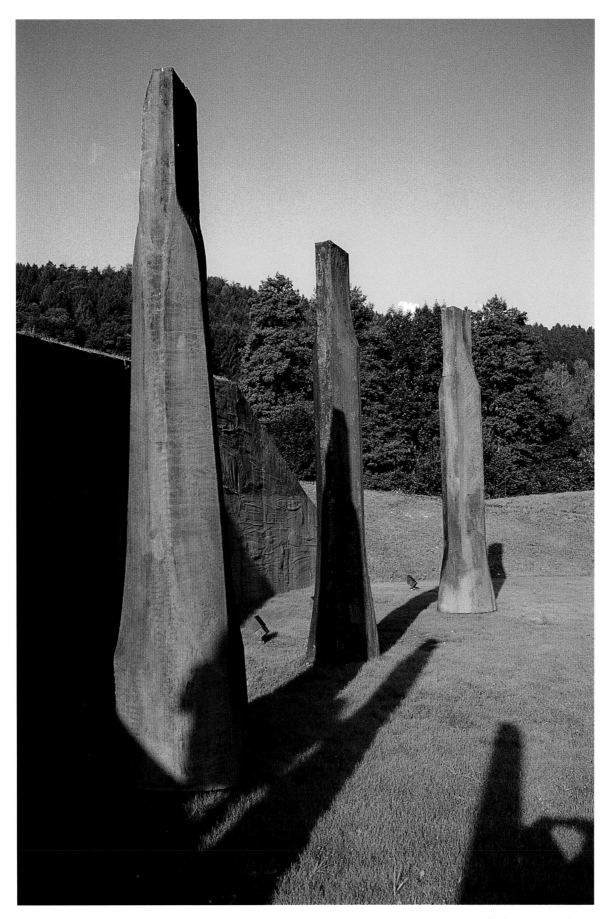

Detail of emerging columns

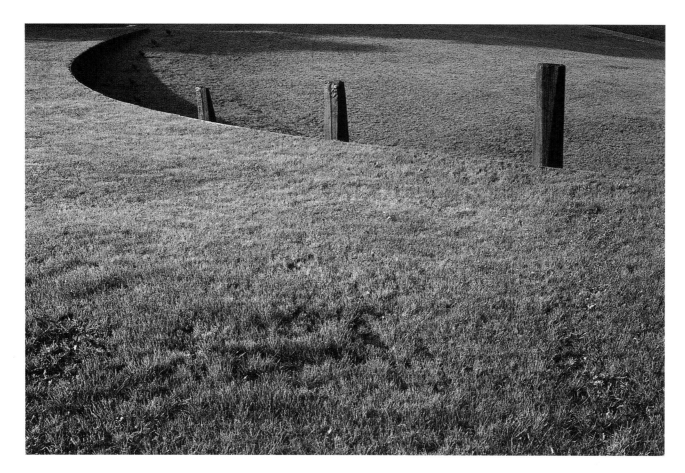

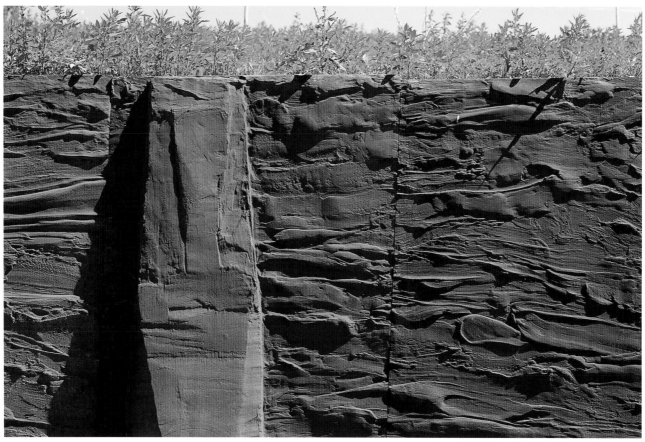

View across lawn (top)

Detail of wall relief

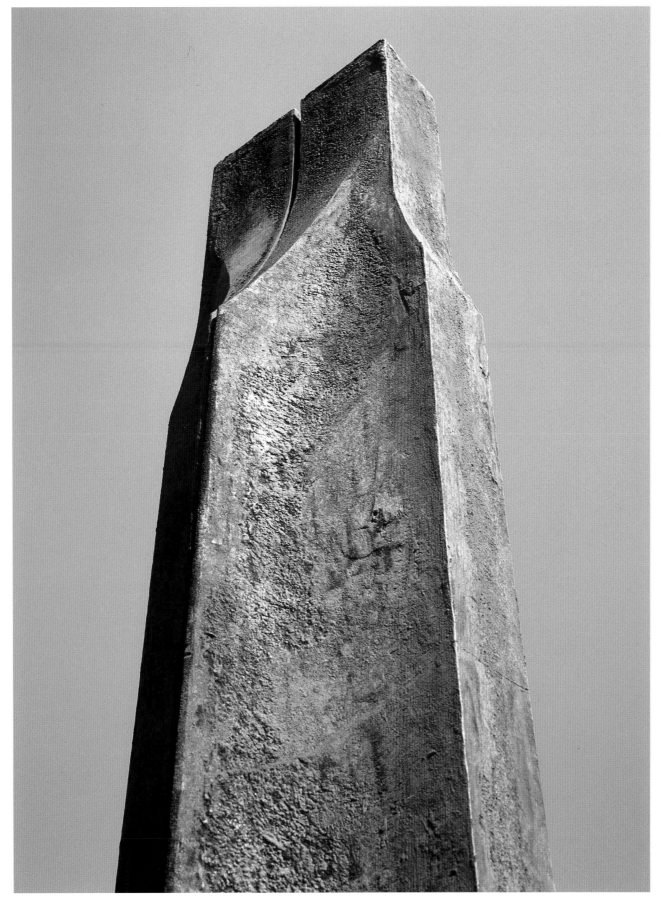

Column detail

46 Sol i Ombra
Barcelona, Spain
1987-92

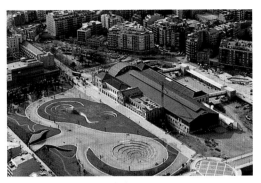

Sol i Ombra Park, aerial view

Watercolor detail of west entry

Wooden model showing column placement

Pepper's ambition to use nature as her canvas and the earth itself as sculptural material had been gradually gathering momentum. In 1984, she began the synthesis of these impulses when the city of Barcelona selected her as one of several internationally known sculptors to create a contemporary monument as part of an urban renewal program in the Catalan capital. She used the opportunity of designing a public park in a rundown industrial area near the Estacio del Nord railroad station to synthesize many threads of her thinking regarding landscape architecture's potential for urban enhancement.

The ambitious renovation program for Barcelona was central to the revival of the Catalan language and culture after the rebirth of democracy following Franco's death. One of the great cosmopolitan capitals of Europe early in this century and the cradle of Spanish *Modernismo,* the ancient capital of Catalonia suffered what *Time* magazine described as "malign neglect" after Catalan independence was crushed during the Spanish Civil War.

Barcelona was the artist's dream project. Oriol Bohigas, the city's progressive urban planner and architect, selected a group of world-famous artists who included great Spanish sculptors such as Eduardo Chillida and Joan Miró, as well as Americans like Ellsworth Kelly, Richard Serra, and Roy Lichtenstein. Bohigas and Josep Acebillo, the program's planning coordinator, gave the artists an unprecedented degree of freedom and control as well as all the technical aid they required to realize their projects.

Ultimately, seventy-two large-scale public sculptures were placed all over the city. According to Mayor Pascual Maragall, the result was "a

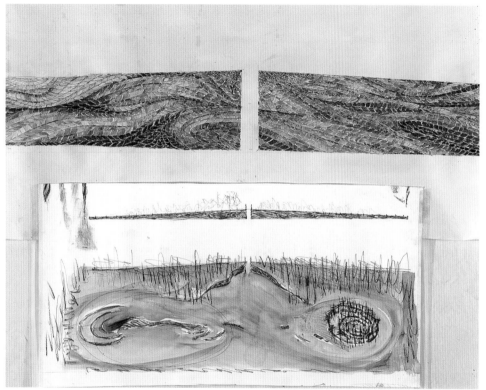

Watercolor of early version of west entry gate

museum in the street." Pepper, however, did not want to simply place a sculpture outdoors, she wanted to create a total environment, which would have a practical public use. She considered her park commission a great challenge that would permit her to integrate many of the elements she had studied and worked on separately. She knew it would be difficult, time-consuming, and elaborately complex. In the end, she invested five years, from 1987 to 1992, in collaborating with Catalan engineers, landscape architects, and artisans to create the huge, 35,000-square-foot park near the abandoned railroad station.

The idea that landscaped sculpture should change with the seasons had been with her since 1976 when she began working on *Thel* for the campus of Dartmouth College. A 130-foot horizontal extension of dramatically cantilevered triangular sections, *Thel* rises from the ground to incor-

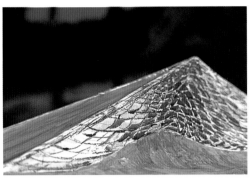
Papier-mâché model of *Cel Caigut*

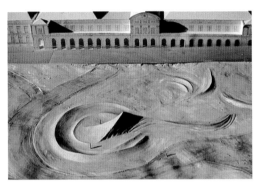
Plaster model

Tile samples

porate earth, grass, and snow. The piece was also among the first of Pepper's works to emphasize the exciting opposition of submersion and cantilevering, which required substantial architectural engineering. The steel triangles, partially buried in the earth, are covered with snow in the winter and grass in the summer, reflecting the extremes of climate in New Hampshire.

Thel followed earlier research into integrating land and art. Her thoughts on the subject were stimulated when Patsy and Raymond Nasher, leading American sculpture collectors, commissioned Pepper to make a public sculpture for a property they owned in Dallas, Texas. The site, a traffic roundabout, demanded a radical solution. Pepper decided that extreme, stretched-out horizontality, with triangular elements not precisely repeated or even echoed in the sense of Cubist composition, was the answer to the long, narrow site.

This solution permitted the sculpture to be experienced even by viewers in a passing car or walking along its edge. It was the opposite of the "all-at-once" impact, which was related to "hard-edge" painting, evoked by David Smith's linear transparency. Indeed, it is possible that Pepper stopped painting in the 1960s because of a visceral distaste for the style of abstraction that Clement Greenberg was championing at the time—concepts that denied the element of time required to "read" sculpture in the round, which had developed not from painting, but from Classical and Baroque antecedents.

Originally, Pepper thought of sinking the sequential elements of the *Dallas Land Canal and Hillside* in sand, but once under way, she decided to use the existing soil as a container for her fabricated Cor-ten forms. The idea had been slowly incubating—a process of slow gestation that is characteristic of her mind,

constantly summarizing and integrating the past in newer work until she feels the problem is either solved or exhausted. A decade later she would once more pick up and elaborate on the sand theme in a temporary work on the beach in Florida.

In the 1960s, she had made a very successful series of elegant, polished stainless works that seemed to tumble or imply movement or gesture. Inside, the cubes were frames so one could see through them in the sense of the "all-at-once" gestalt of Minimal art. The reflective, polished stainless steel exterior was as pristine and elegant as any Donald Judd "specific object"—yet it included the sky, the grass, and even the viewer in the piece. Inside, they were painted an intense sky-blue enamel that gave them an incredible allure and once more suggested the sky, a motif picked up again in *Cel Caigut*, the sculptural element in the Barcelona park.

Recycled garbage creates form

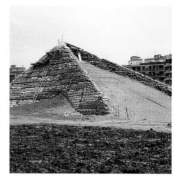
Cel Caigut earthen form

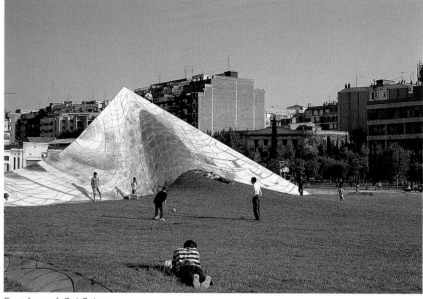
East face of *Cel Caigut*

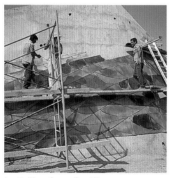
Installing form for tiles

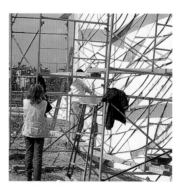
Installing tiles

Inclusion of the landscape through reflection was a theme that preoccupied Pepper for a number of years. As a master artist in an innovative workshop at the Atlantic Center for the Arts in New Smyrna Beach, Florida, in 1986, she directed student apprentices in building a series of wooden, shell-like curved sections covered with silver Mylar to suggest the mirrored finish of her polished stainless pieces. Instead of grass, however, they reflected sand and the sharp contrasts of bright sunlight and deep shadow. Later, she would adapt this theme in an unrealized project for the Barcelona Olympiad—an immense reflective sculpture to be sunk in the hills above the city, spelling out in abstracted, stylized, cursive lettering the name of the Catalan capital.

Pepper christened her Barcelona park *Sol i Ombra (Sun and Shade),* not as an allusion to the bullring, but to the passage of the seasons, making it possible to enjoy and to be conscious of seasonal change. It was the culmination of two decades of research into inserting art into nature in an intimate relationship that compromised neither. *Sol i Ombra* constitutes two opposing elements: the solid, ceramic-covered volumetric earth mound *Cel Caigut* (Catalan for "falling sky"), and the open, transparent *Spiral of Trees*, a descending spiral of plane trees more than 180 feet in diameter that provides a shady contrast to the exposed portions of the park. The graduated sloping rings of the *Spiral of Trees* recalls Pepper's hillside *Amphisculpture* in Bedminster, New Jersey, where concrete rings in descending circles provide seating for the public in search of sun and fresh air. Later, this hemisphere element would be incorporated into an environmental sculpture actually used as a theater in Pistoia, Italy.

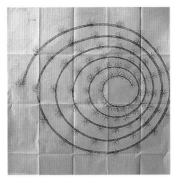

Plan drawing for *Spiral of Trees*

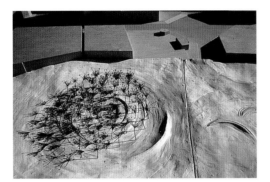

Plaster model

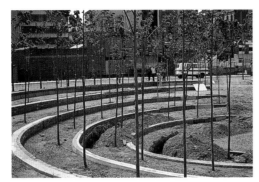

Spiral of Trees under construction

In Barcelona, the flat seating areas are made of lavender and blue tile that recall traditional *azulejos*. Garry Apgar described it in the February 1991 issue of *Art in America* as a "continuous curving multishaded blue ceramic bench, burrowed, like a shallow corkscrew, into the earth." An article in a Japanese architecture magazine refers to the *Spiral of Trees* as a whirlpool, a distinction that may be the difference between the perceptions of a drinking and a bathing culture. The largest element in the park, *Cel Caigut*, rises like a giant wave from the earth around: It recalls both the dramatic imminence of Pepper's unrealized volcano project for Mt. Vesuvius, done for a Naples exhibition in 1971, and the triangles buried in the grass on the Dartmouth campus and in the traffic island in Dallas.

Cel Caigut is content-specific as well as site-specific. In an homage to Gaudí, the great turn-of-the-century Catalan architect, Pepper covered the earth mound with shimmering ceramic tile, the material Gaudí used in his famous Park Güell, where the mountain of Tibidabo rises above the city of Barcelona. Clearly, she was also impressed by the elaborate hand-worked surfaces and the fusion of sculpture and architecture of Gaudí's cathedral of La Sagrada Familia, which was finally being completed almost 100 years after it had been begun. Living in Italy had made her especially sensitive to the quality of artisanship; even her earliest carved wood sculptures are irregular, revealing a human touch. In Barcelona, she was able to develop this concern for the uniquely handmade to an extraordinary degree.

Gaudí's Park Güell and the Sagrada Familia are rich with surface detail, which has become more and more central to Pepper's large-scale environmental projects. Back in her studios in TriBeCa and Umbria, she began furiously drawing. She consciously wanted to introduce the uneven trace of the human hand and the linearity of drawing into a huge environmental project.

Working with Catalan artisans, Pepper experimented to make her colors light and transparent, like watercolor tints—a departure from Gaudí. Ultimately, she decided on variegated shades of blue suggesting sky and sea, since Barcelona is a seaport. Each tile is different, and the variation of color adds to the rolling, rippling effect. The transparent glaze she chose, which had to be brushed on by hand like watercolors, actually reflects the sky which seems to have "fallen" into the piece.

Pepper's tasks ranged from finding the toughest and most resistant grass—both to weather as well as human traffic—to designing seating, lights, water fountains, and gates needed for a park. Pepper found precedent for the thirty-three 13 ½-foot-tall cast-iron lighting columns, with light coming from the interior shaft of illumination, in the 60-foot-high cast-iron sculpture she did for architect Cesar Pelli for a Houston apartment complex in 1981. Once again, an obsession with the continuity of memory caused her to incorporate and build on the past rather than to throw it away in ephemeral works that were the fashion of the moment.

51

52 **Teatro Celle**
Pistoia, Italy
1989-91

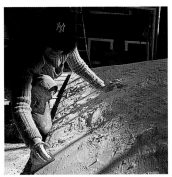

Pepper making plaster originals for casting *Filiate Walls*

Pepper working plaster

Installing tufa stone seating

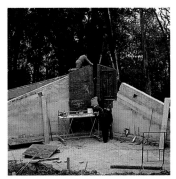

Concrete forms for cast-iron panels

A happy continuity of style binds the works with the earlier ones... It's somewhat amazing that such gifts actually come not from mere taste, but from an interior refinement which knows even the meaning of brutality.
—Clement Greenberg, exhibition review, 1962

Sol i Ombra was an immense undertaking that took five years to complete. It left Pepper both exhausted and exhilarated. She had confronted the challenge of moving from objects to genuinely participatory environments. Even before the Estacio del Nord park was finished, while still commuting back and forth to Barcelona, she began to work on another ambitious landscape project commissioned by Giuliano Gori for his Tuscan outdoor sculpture museum at the Villa Celle.

The project excited her. Like the park in Barcelona, the new landscape project, an outdoor theater, gave her the freedom to experiment with new forms and materials and to work on an environmental scale. She had begun to paint again after twenty-five years and was determined to give as much variety, texture, and detail to her cast-iron relief surfaces as she gave to her paintings. The first

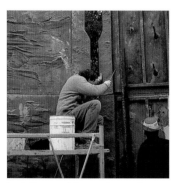

Installing cast-iron columns for *Filiate Walls*

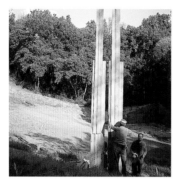

Mock-up for *Precursor Sentinels*

Concrete forms

Installing panels

Approach from woods

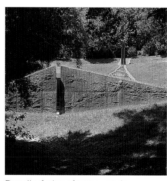

Detail of view from woods

54

problem to be solved was how to create the giant plaster originals used in casting large sections of the iron wall that was to serve as a backdrop for the performance area. After many attempts, she found an industrial foundry outside of Frosinone in south Italy that specialized in the manufacture of machine parts.

Her project called for a tripartite grass, earth, stone and metal installation. *Filiate Walls*, the 78-foot-long cast-iron proscenium backdrop, comprises two winglike triangles, one slightly nearer the audience than the other, and parted so that performers can enter the stage area. Gori usually permits his artists to select their sites, but he had reserved a natural, bowl-like depression in the park for Pepper's amphitheater. He agreed that the stage would be made of rectangular flat tufa stones, but argued with the artist about the tufa stone and grass seating. Pepper

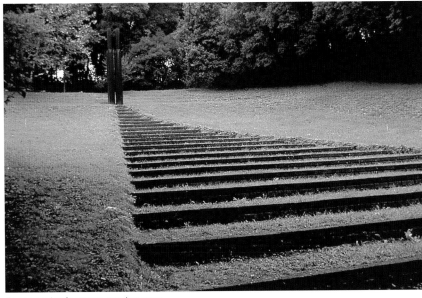

Grass and tufa stone seating area

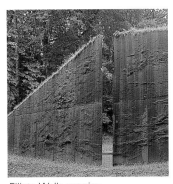

Filiate Walls opening

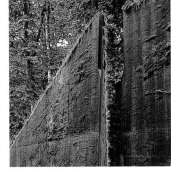

Opening viewed from woods

prevailed, wanting nothing resembling cushions to interfere with the purity of her design for a theater that accommodates as many as 300 spectators for an annual performance. The work, Pepper maintained, must function as a piece of sculpture for the rest of the year.

From the top of the hill looking down on the steps of the amphitheater toward the stage, one has a double vision of the two 16-foot-high guardian columns she calls *Precursor Sentinels*. These serve as welcoming propylaea, echoed by the opening that splits the proscenium. These sentinel figures recall the *Moline Markers*, her first cast-iron vertical totems, and lend a processional feeling to the piece. In this Celle environment, there is a sense of mysterious ritual, of sites and sacred places, of vital points of contact and accumulated energies. The lower stage opening repeats by inversion the form of

the sentinel figures that guard the arena above the ringed seating area, split down the center.

Pepper's inversions and repetitions are never modular. There is no uniformity in the design. She permits accidents that occur to remain, so that once they have been cast, each of the two columns and the 81 panel sections framing the stage are different. The totality looks monolithic, but the irregularity of its surfaces, which require time to read, recall André Gide's admonition to his readers: "Do not understand me too quickly." The oneness and wholeness is genuine, but so is the anxiety and restlessness of nonconformity. This restlessness, which must be calmed if a sculpture is to take permanent form, is one of the characteristics of Pepper's drawings that holds our interest; it speaks to us of the febrile, agitated quality of an inner life con-

stantly in search of the serenity of stable gestalts, which somehow elude her and assume a precarious balance.

Teatro Celle is a landscape environment inside another artificial landscape, the cultivated wilderness of the Romantic English-style park with its man-made lakes and waterfall designed by Giovanni Gambini that surrounds the 18th-century villa. In that sense, Gori's landscape is a double deception—*natura naturans* as the subject for a work of *natura naturata*. The craggy, irregular depressions of the relief panels that form the theater's coulisses are beyond painted scenery. They are a memory imprint, a transfer of the textures and colors of the great natural rock formations of the American landscape that Pepper loves best: the heroic canyons and mesas of Arizona and New Mexico, where she has traveled and worked.

56 Palingenesis
Zurich, Switzerland
1993-94

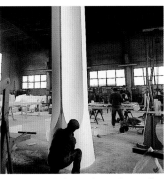

Pepper sculpting column in studio

Grinding cast columns in Frosinone foundry

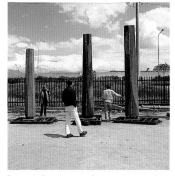

Inspecting cast columns

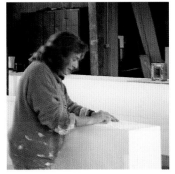

Pepper working plaster

Palingenesis overview

Pepper inspecting castings

There's nothing like experience. The idea is not to be reaction—to be willing to risk change and possible failure. I am always learning. I'm not trying to make a statement, I'm simply trying to do the best piece of art I can.
—Beverly Pepper, October 1994

Visiting Beverly Pepper's studio can be a most disarming experience. It is a minefield of models, full-scale works in progress, fragments, sketches, machines, chains, lasers, plaster, knives, Styrofoam, and a sufficient number of mysterious tools to suggest the *Texas Chain-saw Massacre* or the bedroom of the Marquis de Sade. In the middle of this turbulence, a medium-size American woman in a greasy T-shirt and spattered jeans is scraping, altering, removing, and putting back chunks of plaster that she intends to cast in iron.

Pepper sketches constantly. She changes and revises on paper and then does the same with plaster in her studio. This means that although she makes drawings, there are no specific preparatory drawings to be transferred to sculpture. Nothing ends as it begins. She honors the unpredictability of accident. In her later works, painterly qualities are

retrieved in surface elaboration and the touch of the hand that we enjoy in works by Medardo Rosso, Auguste Rodin, Henri Matisse, and Alberto Giacometti, those Modern sculptors who never lost touch with the ancient tradition of bronze casting.

This involvement with process, with research, discovery, and growth is what separates Modern from academic art. This process of critically reviewing her own work is reminiscent of the way Cézanne worked, yet when it is time to translate the gestural impulse of the drawings into the solidity of tons of metal, the improvisational esthetic of the New York school gives way to practical considerations of weight and physical space. "The major problem with public sculpture is that you cannot afford to make a mistake," Pepper explains. "The work is there permanently."

Pepper is at a loss for a title for a piece she is working on for the Credit Suisse headquarters in Zurich. She has been working on the theme of one element born from another, expressed by a sequence of vertical elements that gradually separate from a wall that generates them. The vertical elements progressively become detached from their context as children individualize themselves from a parent. These themes of genesis and continuity are central to Pepper's iconography. Art historian Diane Kelder is in Pepper's studio studying the various size models and maquettes she is working on for the Swiss commission. Kelder suggests *Palingenesis*, meaning one element seeds the next, as a title for the 227-foot-long landscape sculpture.

Steel armature to hold wall

Wall detail

Installation

Pepper reviewing texture

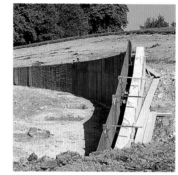
Wooden armatures for cement

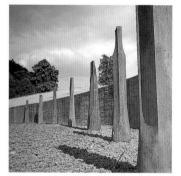
Columns

Each vertical element, which marks the 200-foot-long, curved processional articulated in a solemn and rhythmic progression, is developed from the preceding vertical. Gradually, the seventeen vertical markers disengage themselves from the curving wall until the last seven are freestanding within the space of the curved enclosure, at increasing distances from it. After the midpoint, the vertical elements are no longer engaged columns wed to their originating wall, but detached sculptures, declaring their own independence and autonomy from any confinement, even that of gentle embrace.

The wall itself ends in one of Pepper's characteristic grass-filled triangles, a rapidly sloping hill that becomes an inviting, grassy terrace. The retaining wall is made up of fifty-nine sections of cast iron. Each of these sections can be seen as a separate relief that Pepper has painstakingly worked by hand, first in plaster, then in cast iron, so that the surface ripples and seems to change as the sun casts its shadow at different times of the day. This effect is planned; the passage of time is part of the content of the work, as are the dramatic chiaroscuro effects of the painterly, tactile surface.

Like the relief panels in *Filiate Walls* and the ceramic tiles of *Cel Caigut,* the irregular, hand-worked surfaces of the *Palingenesis* wall suggest the random movements of both sea and sky. Pepper maintains that when the work is read from left to right, it connotes the birth of new forms from the previous element as it morphs into the next. If the eye reverses course to read from right to left, the effect is as if remembering what has been seen. In *Palingenesis,* as in *Teatro Celle,* the idea of antiquity refers not to the cultural forms of the ancients but to the natural forms of prehistoric geological time. The earth berms contained by the irregular cast-iron reliefs are mysterious apparitions that suddenly rise from the ground like the mysterious ziggurats, Druid enclosures, and other sacred places that speak of rituals we do not know. The surfaces, as they rust, become equally enigmatic. Where were these totems made, by whom, and for what? The sense that they have been eroded by eons of natural changes, as water shaped the earth in Biblical times, is part of their look and feel, not of newness, but of experience.

The heart of the matter for Pepper is the relationship of the revealed to the concealed, of the mass to the silhouette, of the solid to the void, of exterior to interior. This is as true for her landscape environments as it is for her individual sculptures. Her interpretation of these themes recalls

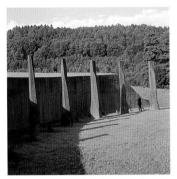

Columns emerging from wall

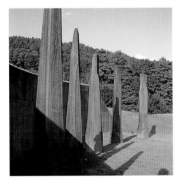

Columns standing free

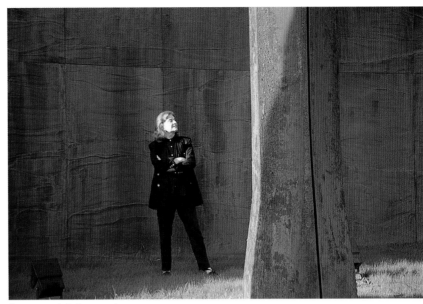

Pepper and *Palingenesis*

the dialogue between art and architecture rather than the counterpoint expressed by Henry Moore's solids versus voids.

Because Pepper's thinking was essentially formed in Paris in the aura of Malraux, who shared views about simultaneous availability with the expatriate French art historian Henri Focillon, author of *The Life of Forms in Art,* and his student George Kubler, who carried the concepts farther in *The Shape of Time*, Pepper was well-prepared for a concept of cultural renewal that was global rather than local, and which took into consideration the interaction between personal style, psychology, and their historic contexts, which variously helped or hindered differing varieties of talent. Chronologically, she is a member of the second generation of the New York School, who worked at a time when serious artists considered public art a compromise no one should

make. Fortunately, she has lived long enough to experience the moment in which her own skills and talent as a sculptor of large-scale environmental landscape works have found a patronage base. It is a moment that artists like Constantin Brancusi, Isamu Noguchi, and Tony Smith, who might finally have realized their lifelong dreams to make a spiritually inspired "art for the people," did not live to see.

It takes a rare studio artist to want to engage with the real world of engineering and landscape, but Pepper is her own kind of anomaly. Success has given her confidence, but not self-satisfaction; she is still pursued by demons that force her to charge ahead into unknown territory, often heedless of the risks. Her fearless curiosity and restlessness have, on occasion, caused her to risk her life in pursuit of a dangerous art

adventure. This fearlessness and appetite for challenge create a kind of demon that she flees not by looking back but by plunging ahead, deliberately ignoring the risks she is taking. Courage and daring are so intrinsic to her character she takes these qualities for granted, as if unaware of their uniqueness in our conformist, timid time.

Pepper's hands are stained with the acid she uses to patina her sculpture. There is still a fleck in her eye where a piece of steel landed while she was working in a factory. There are days when she is distraught, exhausted, empty, but soon she is filled again with new ideas, projects, and enthusiasm. On her way back to Todi from a raid on the local building supply warehouse, she stops by a nursery. The season is changing, and there are new seeds to be planted.

An art critic once said the inspiration for your sculpture and your wall reliefs comes from an "intimate relationship with the earth." Could you describe that relationship? I don't work the earth, but I live through a lot of these landscapes. Though I'm in essence a New Yorker, I'm much happier in the Italian countryside, where I live part of the year. I relate more to the earth there. You could say my work is in conversation with that Italian sense of the earth, that sense of history. But I found years ago that I had to return frequently to New York.

What's the difference between a New York artist and a European artist? American art has a sense of innocence. Even now, in one of our most undemocratic, anti-art moments, Americans believe we are the freest people in the world, and for many years, our art reflected it. European art tends to be rooted in the past. It reflects its sense of history. I try to work at some intersection between those two feelings—trying to erode and corrode the present.

Critics have described your work as a bridge between the past and the future. Some have seen it as very religious or spiritual. I'm comfortable with that idea. I don't put it in the work, but nothing displeases me about feeling that I imbue my work with religiosity—with a very small "r"—that is awakened in the viewer. I am always surprised by it.

The *Manhattan Sentinels* (Pepper's 1997 sculpture in Federal Plaza in New York City) seem monumental though they are surrounded by skyscrapers. There's no formula for how to make a thing monumental. The sense of scale is like the color of your eyes or your skin. In New York, I wanted a sense of other civilizations—that those pieces came from another time and place. You should have a feeling that they were there before the buildings, and that the buildings grew around them. In New York City, everything is within somebody's memory. I wanted to give a memory to a place that had nothing to do with the present place called New York City.

Are you most comfortable working in the colossal scale? I keep trying to make small work. I don't want to make big work my whole life.

Why not? It's like being in the movie business. For big work, you have to find the producer, the writer, and more importantly, the distributor. There's something so enviable about making smaller works—you make them, and there they are.

But I'm not unique among my colleagues who are willing to lose money to make the work the right size for the site. We try to work with the bottom line; we try not to lose money. But an artist can't put up a little sign that says: "Forgive me, but there wasn't enough money to make these sculptures big enough."

Architects and landscape architects begin with a program that defines how a site will be used. Do you think about how the work will be used? Only secondarily. I begin with an inner feeling for what I imagine will work. My solutions can't be mathematically predicted. I often change the configuration while I'm working. If it is a certain way on paper, that doesn't mean it has to be that way three-dimensionally. That's the trick of getting the soul in the work. It's what you feel when moving around, working. It's in the process of making art. You try to feel the site.

Your early sculptures were individual objects or series of objects. What made you turn to site-specific art like *Dallas Land Canal and Hillside, Amphisculpture,* and *The?* I wasn't alone doing site-specific work in the 1970s. There were other people working that way, and it was an example of that strange vibrancy that crosses oceans and countries. In the 1960s, I was photographing haystacks and putting them together as a whole site. I made forms with sand long before I made a sand sculpture. You have to find a patron who is willing to support site-specific work. When I did *Dallas Land Canal and Hillside* for the Nashers in 1972, the gallery was against my doing it. It was such a new concept that they didn't know how to sell it, and they were justifiably worried about how much money I would lose. But like a landscape architect, I said, "Those things I make with my hands, I pay for. The earth and the plants, you pay for." But I cannot be tied permanently to architectural plans. That's the real difference between me and architects or landscape architects.

Mary Miss has said that artists plumb their own metaphysical depths, while designers like architects and landscape architects can't do that.... I believe the prime difference is talent, not depth. Whether you like Frank Gehry or not, he's plumbing his depths. The depths of Richard Meier are white. It all relates to intuition, whether in architecture, landscape architecture, or art. Intelligence can do nothing without intuition. Intelligence alone may define some architecture, but the artist must combine intuition *and* intelligence. Of course, great architects and landscape architects do that, too. Isozaki has that kind of intuition and intelligence, but perhaps even he would rise higher if he were free to use his accidents.

Jean Cocteau said, "Genius is the recognition of the divine accident." Most architects can't risk incorporating the 'accidents' that might occur during building. Any artist worth his or her salt will take that risk. We mine the imperfection we discover as the work grows. I'm sure that's how most great theories, like relativity, were discovered.

When I made fabricated sculpture, I made it in my studio rather than having it fabricated outside to allow for the accident. It's like painting; you start a painting, and you follow yourself as you paint. At least, that's the way I work.

There's another difference between me and landscape architects or architects. They hold everything exactly to the measure. For me, imperfection is no barrier. In my house that I restored in Italy, I had the workmen use glasses of water for levels. We used every kind of primitive tool that might have existed in the 14th and 15th centuries because I wanted to have that effect. The walls aren't absolutely straight, and the house has a sense of time. Had I restored it with modern tools, it would have looked *restored.*

Do you think there is any cross-fertilization between artists and landscape architects? You made a plaza on one side of the Jacob Javits Federal Building, Martha Schwartz made a plaza on the other side... No, I didn't go around that side. I prefer to fumble on my own. I am a lump of insecurity if I'm working with a lot of people around—I'm not a collective person. The first time I saw a kibbutz, I asked the people how long they had to stay there. It was like a jail to me.

In 1969, you participated in a land reclamation project in Seattle.... It was called the Mount Lake Landfill—a garbage dump at the University of Washington. I asked them to get me a core sample from the dump, and they collected a 10-foot-by-18-inch strip. The most astonishing thing about contemporary garbage is that it doesn't disintegrate because it's largely plastic. So I thought, why don't we make a viewing chamber into the garbage dump? I designed a huge hill with a center section that would incorporate a complete reconstruction of the inside of the dump—to be about 30 or 40 feet long and about 15 feet high—encased in glass. It would also have openings on the top and bottom. Slowly, with the passage of time, the roots from the hillside would creep into it, eventually resembling a Jackson Pollock painting. On each side would be two core strips, also encased in glass, but completely sealed. They would remain that way, like a painting, forever.

Unfortunately, the land was owned by the Audubon Society and they refused to let the university build it because they felt it would disturb the birds. We gave up.

What do you think about using site-specific art as land reclamation? As a citizen, I'm a strong supporter of land reclamation. These projects have immense artistic potential. I see abandoned gravel pits, which we all assume are big ugly scars on the landscape, outside Rome or on the road to Santa Fe. They have grown into mysterious, almost pagan places. Now they are removing the gravel in setbacks, and one can see how beautiful these casual, wonderful accidents are. I would like to reclaim large coal-mining sites and turn them into public environments.

Robert Morris once wrote that what distinguishes art from other organized human activity is that it doesn't seek control through explanation, but offers the freedom to experience and question—yet this freedom is not always welcome to art's audience. I absolutely agree. I don't make art for other people, and I don't make art for an audience. Nor do I do it against them. It's not my personality to make hostile work. Anyway, if we make things the audience agrees with immediately, we've given them an old experience. They've learned nothing, and we've learned nothing.

How do you begin to make something like *Teatro Celle* or *Palingenesis* or *Sol i Ombra Park* in Barcelona? Do you start with sketches? Do you design in model? Just look through my notebooks. I scribble and think. I often wake up in the middle of the night with something designed in my head, full-blown. Then I start to play with it. I spend a lot of time not working. I just allow my head to work on its own. Frequently, I make a model before I begin drawing. It can be clay or Styrofoam, cut paper or cardboard, whatever. I sit around and I do this [making motions with her hands as if modeling]. Most of the models are done on the kitchen table, not in my studio. At night or in bed or on planes, I'm always doing this kind of thing.

With *Teatro Celle*, I had to outwit Giuliano Gori. He is justifiably fanatic about his gardens, and he didn't want me to touch the land. I removed two trees before he could tell me they couldn't be taken down, added 50 centimeters to the height of the work when he wasn't looking. The seating is made of tufa stone, from lava. Over the years, it grows a kind of moss and becomes green. It emphasizes the sculptural aspects of the work, rather than its use as a theater.

Did Gori request a theater? Or did the theater evolve from the site? He wanted a theater and had been saving a piece of land for it. He had seen *Amphisculpture*, but that wasn't going to work in the Tuscan landscape, and *Cel Caigut* in *Sol i Ombra Park* in Barcelona, and he had a sloping hill site. I had done works in the round before. I did *Cromech Glen*, a spiral piece using grass at Laumeier International Sculpture Park in St. Louis a few years earlier. And the late Pietro Porcinai, Italy's esteemed landscape architect, suggested I do the sculpture-theater.

And in Barcelona, did you also "follow yourself?" Yes, but Barcelona was a rare experience. In Barcelona, I was surrounded by Gaudí. Also, the site was 35,000 square feet, which is a little bigger than two American football fields. I had never used ceramics, but because of the tradition in Catalonia, I wanted to try them. I didn't want to use them the way Gaudí or Miró did, with tiny little flat tiles of primary colors. I wanted to do something that was an homage to both of them, but had nothing to do with the way they worked.

Did the city of Barcelona give you a program or specify that the park should have seating? They said, "Make something. We want a park that is also sculpture." I was more or less given carte blanche—and assigned two terrific young architects, Carmen Fiol and Andreu Arriola, to help me realize my projects.

The park incorporates recycled rubbish. Was that your idea? Only in part. In Barcelona, they make ashes of recyclable garbage and put them into sacks which they use in road building. Originally, it wasn't part of the project, but I incorporated it. What I didn't know was that they rarely use grass in parks, preferring pressed earth, *saulo*, which I use as a counterpoint to the grass. Unfortunately, maintenance is rarely addressed, and the grass triangle in the park in Barcelona has been destroyed twice because they allow kids to ride up it on motorcycles.

In parks like *Sol i Ombra* in Barcelona and *Manhattan Sentinels* here in New York, do you choose the species of trees that will be planted? Yes. In both places I wanted trees that lose their leaves. I wanted to see seasonal change— a sense of the unfolding of time. I have not seen the *Sentinels* in the snow, but I hope they look terrific. When there are no leaves, they should look like three-dimensional line drawings circling the sculpture. I always prefer leaf-shedding, deciduous plants.

Why do you like that sense of change? Public art is seen over and over again by the same people, and if it is a daily experience, there comes a point where they no longer see the work. You know how wonderful it is in spring to see the buds, and then to watch the leaves come out, and to enjoy their changing colors. I've designed sculptures where the plantings were for different seasons—purple, yellow, green—so they engage people to look at them. Otherwise, the work becomes anonymous. That's why I say "public art" is an oxymoron. Art is about personal involvement; it's not like airport "art"—people running through, not stopping. Art is supposed to be contemplative; it is supposed to transport you.

Does the rust in your sculptures also promote that sense of change? I hope so. Rust is a material that belongs to prehistory. Everything becomes iron. Even a tear becomes iron over a million years. Iron has its own life. It's almost a primitive material. It says, "Here is what you've got, and I'll be here forever." It moves and lives on its own.

Robert Hobbs wrote that when you made *Amphisculpture* in 1974, you were fascinated by the Space Age, and that when you made *Teatro Celle*, in 1992, you were less enamored with space and seeking to elevate simple tools. I really wasn't fascinated by the Space Age. My work is always about space. I'm interested in the space within as well as the space without. That's what led me to make sculptures in the landscape that you can walk through, in, around, and down.

Tools have always engaged me. Perhaps it's the accumulated memory of a tool. After all, they are almost an extension of myself. They are in my hands all the time, and sometimes they provoke me into metamorphosizing them.

How do you mean, 'provoke' you? Tools are works of art in themselves, but I don't want to simply repeat their forms—they are a point of departure. Look, that started as a file [pointing at small piece in the studio]. That over there is a kind of hammer. Those *Urban Altars* are double-headed axes. I went to Herbert Hoover's birthplace, and they had this axe in his barn, a beautiful axe! I bought two of them, and I put them together. Then I started changing them, and they became altars. I call them *Urban Altars*, because one has a sense of silence and selfhood when standing before them. It may also be that the axe refers to the violence of our time.

But I don't intellectualize, what I do. I'm a visual artist. I have a major problem with understanding a work of art by reading about it. Nor do I believe one should have to provide an explanation for people to react to a work.

Are you saying you don't care whether people understand the ideas behind the work? I don't always understand the ideas behind the work! And I don't believe in a mass understanding. One person understands something; another person sees it differently. One of the great things about abstract art is that the observer brings himself or herself to it. Of course I'd like others to see some of what I see in the work, but even I am not consistent. Some days I experience the work differently.

Do you think sculpture can change people? When I started making art, I thought it could change the world—that art would make an enormous difference. As time has passed, as the global village has grown, I think artists speak to very few people. It may appear differently in New York City, where the museums are crowded with people during blockbuster shows. But I wonder how much we really do change people—if at all. They have so many other distractions. Television is one information highway, and now we have another, the Web. In the era of Giotto or Piero della Francesca, there were fewer sources of visual information. The relationship between an artist and a viewer had a sense of magic. Artists may still have the power to touch a few people, but I doubt art can change the world.

At the same time, Chaos theory suggests that the flight of a butterfly in Indonesia can stir up a storm in North America. So perhaps artists are the butterflies—who knows?

Who are the artists, living or in the past, whom you admire? It's a question that is difficult to answer. The question should be more like, 'to whose work do you relate?' I admire Michelangelo and Piero della Francesca, Henri Matisse, Kasimir Malevic. I think that David Smith was very important for changing the way artists approached sculpture. The thing that astonished me about Brancusi was to find out how few ideas he had, how few works he did, and how often he reinvented them. I like di Suvero a great deal. Richard Serra's indoor work is extraordinary. What I'm saying is that there are some pieces of work that move me, and I can talk about that particular piece of work.

Yet so much is inspiring. I was just in Paestum looking at temples, Greek-Roman ruins. When I looked at my photographs of the ruins, I was stunned to discover they resembled my own work. I am constantly moved by antiquities. For example, there is something that ties us to eroding stone—as if it has stopped time.

You give your own work a sense of antiquity and age. How do you think your work will be viewed 200 years from now? I never go back to look at my own work because I am usually dissatisfied. I saw *Manhattan Sentinels* when they went up, but I haven't been back. When I finish a piece of work, I'm ready for the next, and I bring my past experience into that piece. Work I have finished is very distracting for me. It's never as fully realized as I wanted—though years later, I may like it.

Do you think about doing some works differently if you could do them over again? I think, 'It should have been better.' In Barcelona, I would now find another solution for the disintegration of the grass triangle. But you can't live with one piece of work for the rest of your life. Bonnard would constantly repaint his pictures. Then he'd bring his paintbrushes to shows to alter the work if he felt like it. And Matisse would have his mistress clean off the paint one day, to leave a pentimento underneath for the next day. Then he would get on with it. Some people write one book in their lifetime, rewriting it in other books.

I prefer an empty slate. I love being in my studio when I've sent the work off. I walk in, and it's completely empty, and I have to fill it up again. At a certain point in life, you're in danger of experiencing what Clement Greenberg called *troppo gusto*, too much taste. You have to go against yourself. I'm also masochistic about my work, always pushing and testing myself. I envy people like Cézanne or Morandi or Giacometti who did the same thing over and over again, but found something new each time.

Your earlier work incorporated triangles and other geometric shapes. Now you seem to have moved away from such shapes.... I connect one thing to another. After much looking, I eventually see something else in it. One shape informs another shape. Let me show you [taking paper and pen]: I did sculptures that were like this [drawing boxes arranged at varying angles to one another]—these are all squares or rectangles, okay? Eventually, I began to see

this shape [a triangle] inside that [two boxes at angles to each other]. I started to work with the internal shape—the triangle. At one point, the triangles were standing upright, and then I cantilevered them until they hit the ground, and finally, I took them underground.

So where are they going next? Both up and down. I do ground-oriented sculptures, and I tend to work in two directions. *Palingenesis* incorporates both.

What does the name *Palingenesis* mean? *Palingenesis* means that 'the seed of the next is in the last.' Here, it's the birth of a sculpture. And in many ways, *Palingenesis* defines my own work, what we've been talking about just now. If you look at my work over time, as with any work done over a lifetime, the sequence of forms shows a progression from one piece to the next. In *Palingenesis*, the wall relief starts with the embryo of a sculpture. It grows and grows until it comes off the wall and becomes a column. I wanted to make something dynamic, something that had to do with filling a landscape.

When the *Palingenesis* wall was finished, the columns emerged—the same columns I have here, all around my studio. They are always my columns. This time, I wanted them to be solid and slowly open until they were split lengthwise with a space in between.

Tell us about the texture of the surface in *Palingenesis*—does it recall painting for you? In a way, yes. It's made in plaster first, and is somewhere between painting and sculpture. As you know, I was a painter for a long time, and I get physical joy out of this tactile involvement. Like painting, the wall reliefs are immediate. I may work on them for days and weeks and months, but I don't have the constraints of final stability, of holding things together. It's also like drawing. It gives me great joy. They are difficult to do; because they are immediate, they call for constant vigilance. In making sculptures, there are often delays that result in your having to go back in time, back into the sculpture. There is so much 'then' that becomes incorporated into it.

Why do you like to work in metal rather than stone? I don't make the work myself if it's in stone. I'm autodidactic; it would take a lot for me to learn to carve in stone. It's not my personality to chop-chop. I have made works in stone, but I did not do the actual carving, and I like to be in control. When we made the *Basalt Ritual* [Pepper's 1986 work in stone for the Koll Center in Irvine, California], I was there directing the carving. Sometimes I patina metal to look like stone, because I can then get something closer to what I want. But I'm not a carver, except in wood, of course.

Where in your work across the years is the clearest image of yourself—a self-portrait? All the work we do is a sum of our experiences. Some people work against themselves, some people work with themselves. Over the years I've accumulated visual archives. Something I recall or repeat becomes a signature of mine—cast iron, grass, the triangle, a 'space between.' Everybody's art is a self-portrait.

Beverly Pepper 1985-88